ROBERT STIVERS

ROBERT STIVERS

ROBERT STIVERS

PHOTOGRAPHS

A.D. COLEMAN

BENEATH EVEN THE OLD ADAM

THE PHOTOGRAPHS OF ROBERT STIVERS

Blind, we might learn wisdom

— Jim Morrison

WE TEND TO THINK OF OURSELVES AS HAVING BOUNDARIES, define ourselves by our borders. Physics tells us otherwise, insists we have no edges, speaks of our molecules as always in motion, a constant atomic interchange, no way to distinguish a proton of yours from a proton of mine when we're making love, holding hands, passing by. That's not the way we see it, of course—or, more precisely, not the way we learn to see it; if William James is near the mark, then we all start out engulfed by the "blooming, buzzing confusion" acquiring over time the ability to narrow down. Sometimes we call that capacity *concentration*; sometimes we call it *focus*. And we tend almost automatically to use the adjective *sharp* in relation to both terms.

Certainly that's true in photography, whose practitioners— deeply if unconsciously affected by a western tradition of realism that defined itself by detailed depiction, as well as by our species' ocular development—have tended to emphasize the medium's capacity for precise delineation of infinite tonal gradations, crispness of line, and

1

sharpness of focus as not only options but requirements. Indeed, some of the key debates among performers in this medium over hermeneutic issues—those between Peter Henry Emerson and Henry Peach Robinson in the 1880s, and between Ansel Adams and William Mortensen in the 1930s—centered around the question of the very legitimacy of any approach to the lens-based media that did not keep everything in the image in absolutely sharp focus.

Which is to say that the matter remains far from resolved. Yet, in fact, one can now look back at more than a century's worth of active photographic investigation of what we might call other-than-sharp approaches to photography as constituting a *de facto* lineage, if not quite a recognized tradition.

If we established its beginning with the unavoidable ghostly blur of things in motion registered in the long exposures of the medium's early pioneers and the smears consequent to inadvertent camera move-ment, we might then look to the shallow depth of field and selective focus advocated by Emerson as more akin to the way the eye perceives, and subsequently to the overall softened focus preferred by many of the turn-of-the-century pictorialists, who used specially designed lenses to achieve that effect.

Next we might move forward to the out-of-focus experiments of some modernist Bauhaus and surrealist works—thereafter attending carefully as one or another of those techniques crops up in mid-century bodies of work as different as those of Nell Dorr, Frederick

Sommer, Lotte Jacobi, Van Deren Coke, Ralph Eugene Meatyard, Lillian Bassman, the so-called New York School (Robert Frank, Alexey Brodovitch, Sid Grossman and others), finally considering how this tendency now informs contemporary work by Nancy Rexroth, Bill Jacobson, Ellen Brooks, David Levinthal and others today too numerous to count.

It is out of this continuum of inquiry that the photographs of Robert Stivers come, and in that context—among several—that they must be understood. Yet I do not wish to weight them, or him, down too heavily with that ancestry. Or at least not exclusively, because other inheritances pertain here. So of course it matters that these are accomplished photographs by someone who has mastered that craft and chosen a particular approach to picture-making that, though controversial in some circles, has substantial antecedents and claims to legitimacy. But it's no less crucial to know that these are also a dancer's photographs, and that their maker thus confronts and speaks to a nexus of other relevancies as well.

> *The evolution of Stone-Age man entailed a gradual dominance of vision over the other senses . . . beneath our visual selves, beneath even the old Adam, lies buried that mammalian and pre-mammalian self, which feels and smells and intuitively or instinctively apprehends. When the dominating eyes are blunted, these "older" senses again become the masters, and to that extent a new persona is born.*[1]

> — Patrick Trevor-Roper

In the Western tradition, performing artists—actors, dancers—used to believe in that same sort of fixity to which a majority of photographers more recently pledged allegiance. Within the classic traditions of their art forms they trained themselves to strike and hold a repertoire of clearly delineated poses that their audiences recognized as significations. The nineteenth-century fad for *tableaux vivants*—costumed human figures frozen in familiar genre scenes—turned that prevalent tendency into a popular parlor game.

Epistemologically speaking, this was a metaphysical approach to performance as a metaphorical equivalent of our being in the world; premised on essentialism, it posited the individual living performer as a necessarily poor, inferior version of some abstract notion, in real life aspiring always to achieve the imagined ideal—a perfection that existed elsewhere, in some Platonic world of forms. Modernist and then post-modernist performance theory changed all that, proposing a more dialectical relationship to the task, positional and contingent. The Actor learns to blur the edges between the self and the role, to become permeable, absorbing and absorbed by the Other. The Dancer considers flux, trajectories, and strategies for occupying space rather than destinations. Often they use vocabularies that seem to connect them more with architects, sculptors, musicians, poets, cartographers, physicists than with the originators of their disciplines. And ways of thought shape modes of action.

We as audience have changed as well. No longer do we weigh

performers automatically against abstractions and ideals; indeed, increasingly, excepting those who practice the most classical versions of their crafts, we do not even gauge them in relation to their predecessors and peers. Instead, we look for their capacity to deliver whatever the work requires in their own authentic voices—to take and reveal to us the full measure of themselves, with all their idiosyncrasies and flaws, rather than measuring up to someone else.

Photographs, by their very nature, ask us to experience the world through someone else's perceptual system, to consider it as seen with someone else's eyes. In all cases, this assumes the filtration effect of the biases of the photographer. Yet what happens when we add to that analogue of personal vision, as Stivers does, a specific perceptual handicap or flaw—the inability to focus?

Individually and as a group, Stivers's images replicate the phenomena of *myopia* and *hypermetropia*—what we commonly call near- and far-sightedness, respectively. The near-sighted person cannot focus on distant objects; the far-sighted one has the opposite problem. Affliction with one or another condition is common, and of course affects one's performance as a visual artist: Holbein, El Greco, Monet and Modigliani are only a few of those whose work gives clues to possible optical problems.[2] I know of no study of the effect of these conditions on performing artists, though there are surely enough eye-glass-wearers among them to indicate that such a query is hardly irrelevant. That's especially so since these physical traits also have profound

if largely unconsidered psychological consequences; these manifest themselves in personality types: "the studious and rather withdrawn myope and the extroverted hypermetrope are familiar figures," as Patrick Trevor-Roper remarks.[3]

Notably, both conditions alternately rule these photographs; regardless of its apparent distance from us within the frame, no object appears in sharp focus, and no foreground-background relationship suggests even the possibility of a progressive clarification. Since these are the basic visual cues by which we locate ourselves in physical space, the world according to Robert Stivers is thus an anxious place in which the vision of all is impaired, and in which no one, introvert or extrovert, can immediately feel entirely comfortable or secure.

How, then, might one negotiate one's way through an environment in which everything floats eerily and unresolvedly in ambiguous darkness? It is here that I think Stivers brings to bear his knowledge of two distinct media, because if I understand this suite of images aright his dancer's answer to that question is: with a dance.

The dance he proposes and encourages here is not merely a dance of the eye—not uncommon in engaging with photographs—but an imaginary dance of the whole body. The elimination of hard edges works against the two-dimensionalizing tendency of the crisply focused image, turns his subjects from shapes into forms, emphasizes the volumetric aspect of them, locates them in a cavernously deep space, proposes them as shifting and mobile, and challenges us to adapt

to them by a perceptual and psychological positioning process not dissimilar to the improvisatory dancer's strategies for relating to the space of the darkened stage, the spotlit cone of concentrated attention, and the other forms—animate and inanimate—that occupy it.

One cannot simply see one's way across these pictures; one must think and feel one's way into, around and through them all but blindly, almost as if one were the dreadfully vulnerable, exposed spine and pelvis that figures in one of them. They demand the application of a whole-body consciousness, a confidence in one's own sense of balance and a trust in one's ability to read fragmentary, partially glimpsed gestures. If ontogeny does indeed recapitulate phylogeny, as Darwin proposed, then this process's evocation of the infant's struggle to organize visual experience in some way mirrors our species' struggle in learning to use our eyes. Perhaps this enforced encounter with "blunted sight" awakens those "older senses" of which Trevor-Roper speaks, calling forth a haptic sensibility that, as he suggests, our emphasis on visuality suppresses.

This brings to mind Richard Boleslavsky's "six lessons" on acting, a distillation of what's come to be called the "Method."[4] In the very first of these radical tutorials—which are surely as germane for dancers as they are for actors, and have been used by at least one great photographer in his own pedagogy[5]—Boleslavsky speaks to the performer's need to "concentrate spiritually" and "possess your own senses," going on to discuss "the education of the body" and the acquisition of an

understanding of "the psychology of motion."[6] And in the second lesson, on "Memory of Emotion," he speaks of the imperative of "eliminating details"[7] in teasing out the core of motivation and purpose—much as a certain precision and amplitude of data have been reduced here, in order to emphasize the archetypal and mythic, mandating a primal response.

The more minutely you describe, the more you will confuse the mind of the reader and the more you will prevent him from a knowledge of the thing described.

— Leonardo da Vinci, Notebooks

As we all learn, fixating on detail can stabilize us in a situation of disorienting visual swirl. Yet that whirl is the visual constant of the real world, and we need to be able to keep our bearings in it and survive. Succumbing to what James Beck has called "the tyranny of the detail"[8]—which he ascribes, in considerable part, to the omnipresence in urban culture of two-dimensionalizing, sharply focused photographs—risks atrophying our capacities for a fluid, contingent interaction with the ever-mutating world before our eyes.

Without denying the periodic value of close and careful scrutiny of things held still, one can say that seeing is not a process that benefits from stasis. According to specialists, it's unlikely that, if our eyeballs and bodies were immobilized and what was before them

stayed absolutely still in unchanging light, we'd ever learn to interpret the signals transmitted from retina to brain. Our eyes are in constant motion in their sockets, our sockets move as our heads accompany our bodies, light fluctuates constantly and much of the stuff of the visible world alters its place and shape as well. Seeing, then, is a relativistic, positional procedure—a dance of the eyes and, by necessity, of the body that houses them.

A mentor of mine, a Zen master disguised as a failed writer, once stopped me in my tracks on a sunny spring day as we strolled the Lower East Side in New York, so that he could teach me a lesson. We'd been talking about the study of art. "Here's how I look at a sculpture," Charlie Devlin said suddenly, instructing me to stand stock-still; and, as passers-by gaped, he proceeded to bob and weave around me for ten full minutes, even jumping up in the air and getting down on his hands and knees to achieve different vantage points. It was a virtuoso rendering of the choreography of observation, an analytical cubist's lindy-hop. No one had ever paid such close visual attention to me as a physical object in my life. "I look at a person the way I look at a sculpture," he told me when he'd finished. I never looked at either the same way again.

I think that Robert Stivers's ambition here is to help us relearn how to look at things by teaching our eyes to dance, using a photographic version of those exercises that instructors in the craft of movement employ to instill and/or refine the ability to respond inventively

to new and unpredictable configurations. Spun around, unmoored from our reference points, off-center, stripped of the comfort of clarity and specifics, we are thrust abruptly into this astigmatic dramaturgy, rife with hints of ancient ritual, elemental forms, animal spirits, charged objects, celebrants and mourners, births and sacrifices, rushes and pauses, gaps and proximities. Once in this illusionary space there is no way out save through, no choice but to join the dance, listening to those "older senses," allowing that "new persona" to be born, fully alive and squalling like the infant you'll meet there, who doesn't even know yet that he has eyes to see.

A. D. Coleman
Staten Island, New York
May 1997

NOTES

[1] Patrick Trevor-Roper, *The World through Blunted Sight: An inquiry into the influence of defective vision on art and character* (London: Allen Lane/The Penguin Press, 1988), pp. 15-16.

[2] Ibid. This is one of the major subjects of this study.

[3] Ibid., p. 21.

[4] Boleslavsky, Richard, *Acting: The First Six Lessons* (New York: Theater Arts Books, 1933).

[5] Minor White famously assigned Boleslavsky as one of his basic readings for photography students; not irrelevantly, he also experimented in his workshops with having both aspiring photographers and professional dancers attempt to "dance" various photographs.

[6] Op. Cit., pp. 22-26.

[7] Ibid., p. 43.

[8] Beck, James, *The Tyranny of the Detail: Contemporary Art in an Urban Setting* (New York: Willis, Locker & Owens, 1992). See esp. pp. 196-205.

PLATES

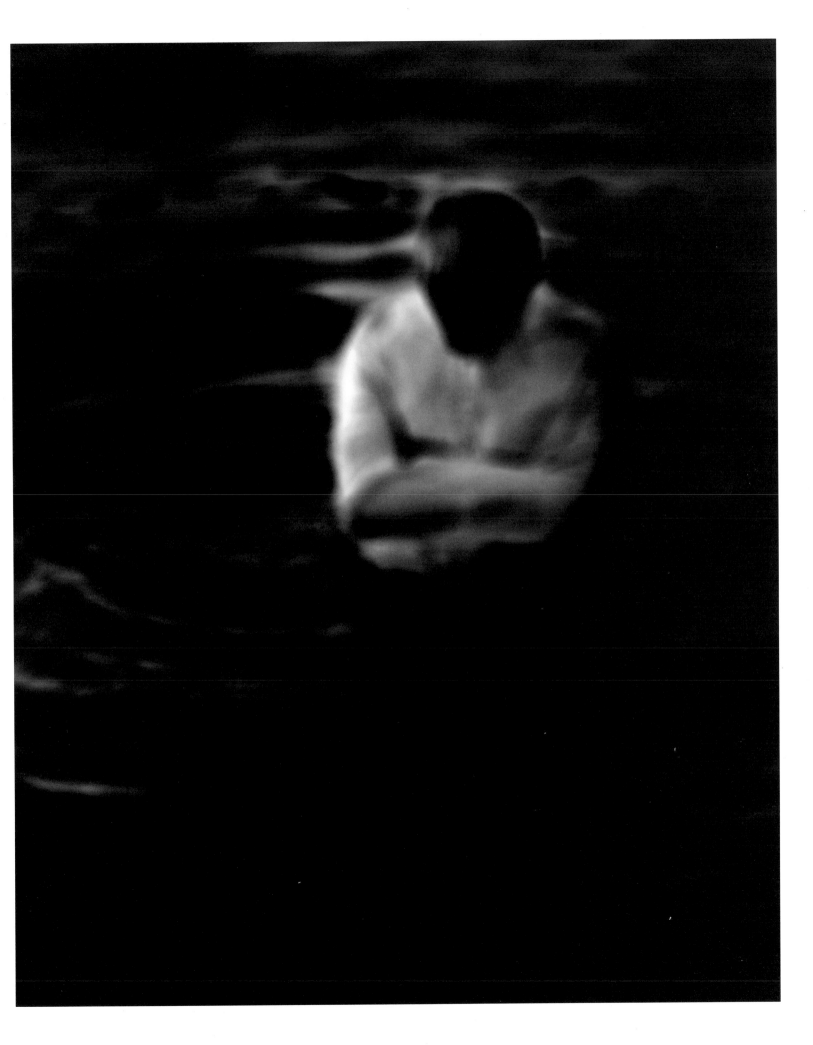

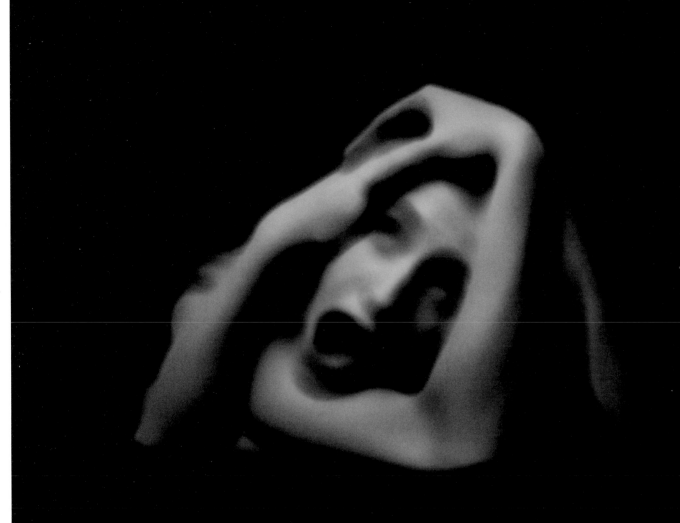

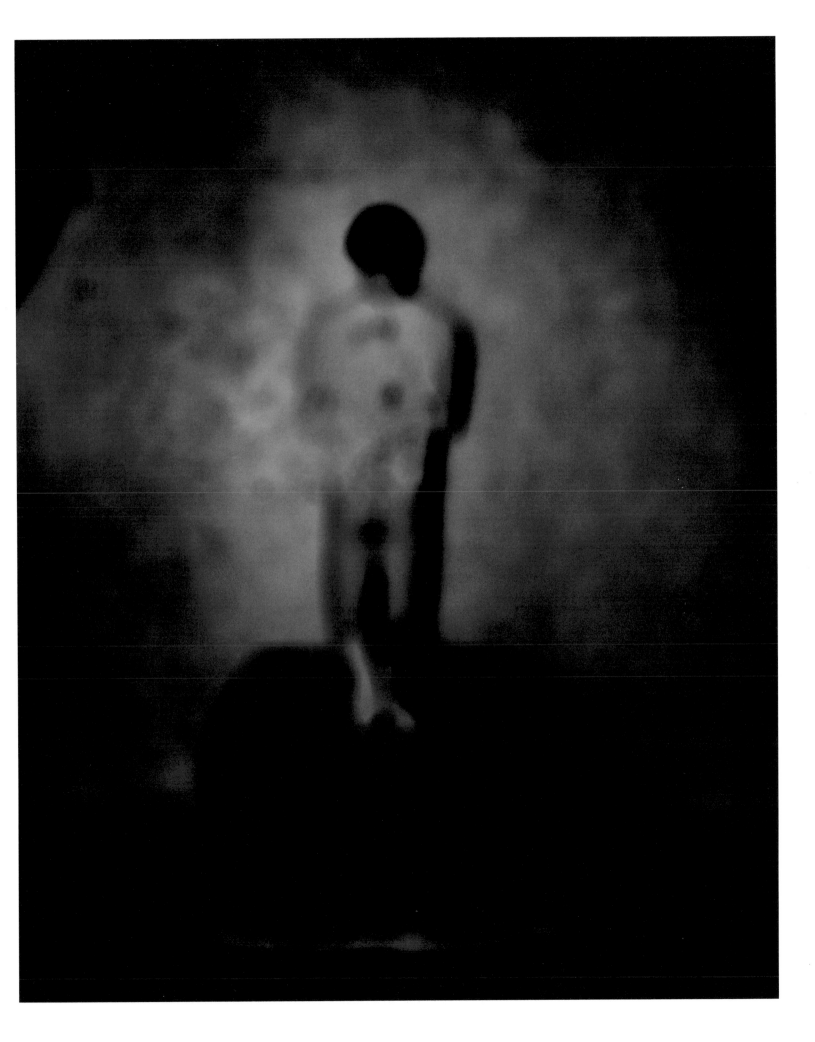

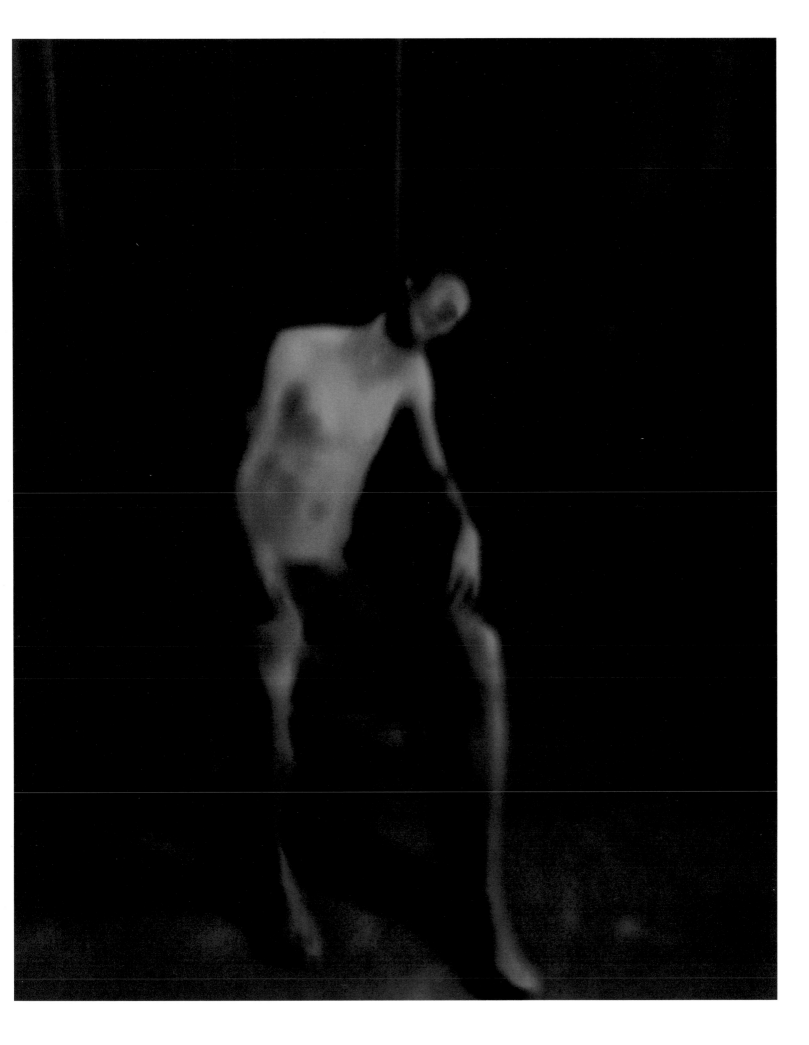

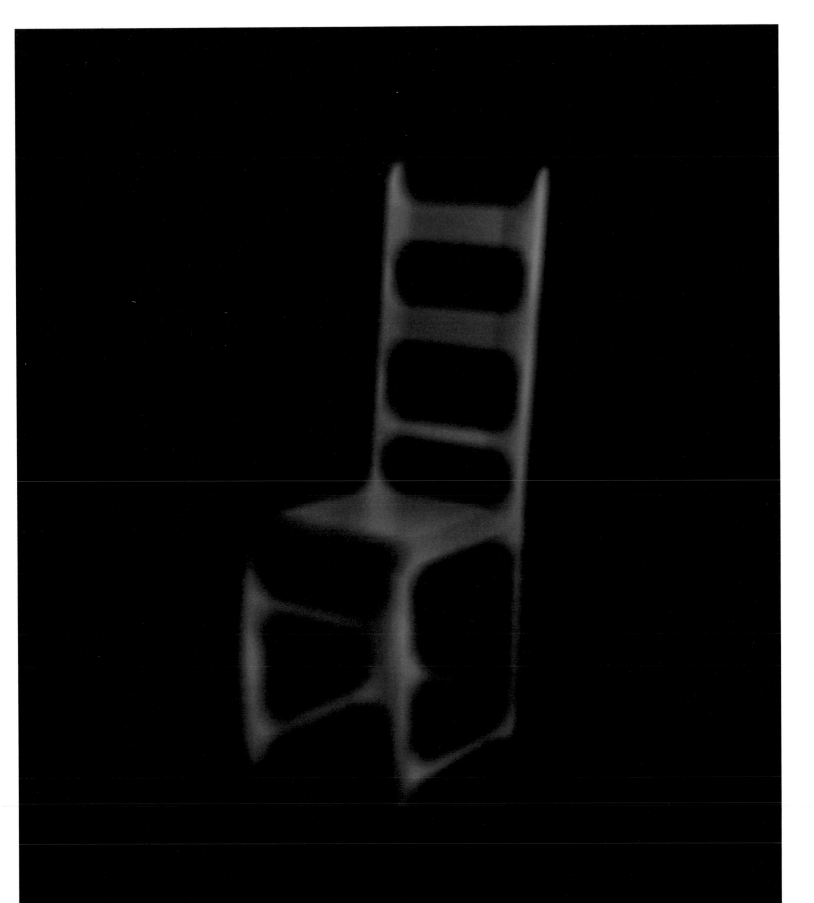

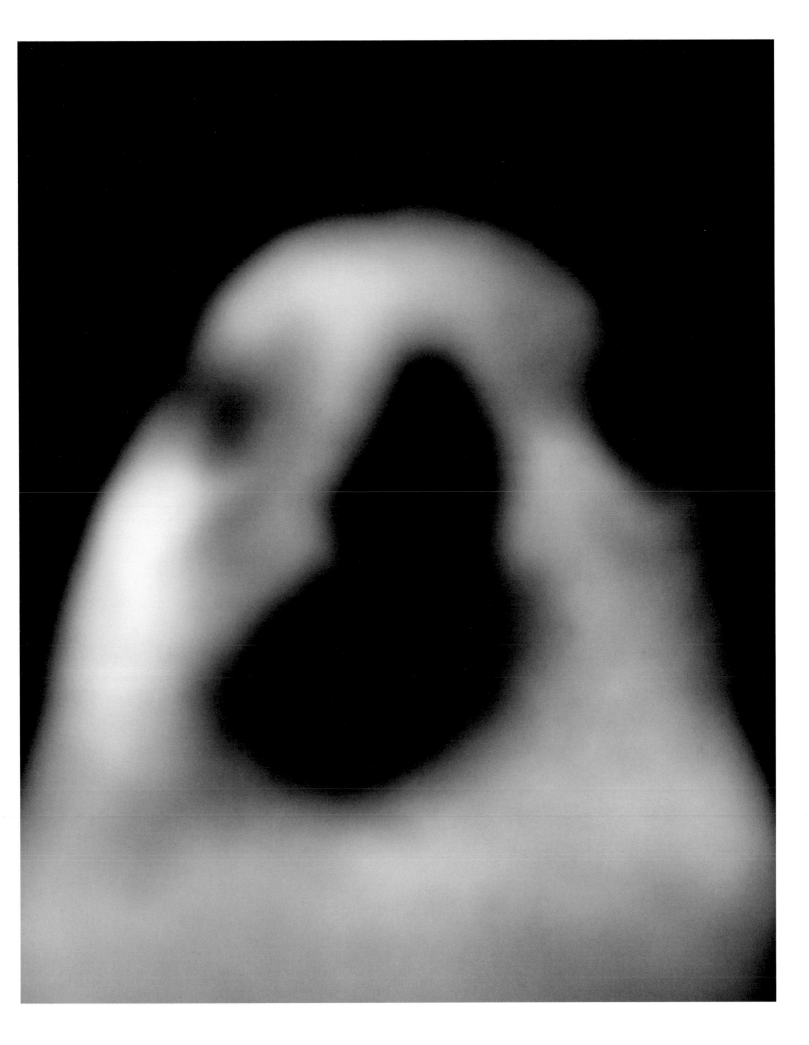

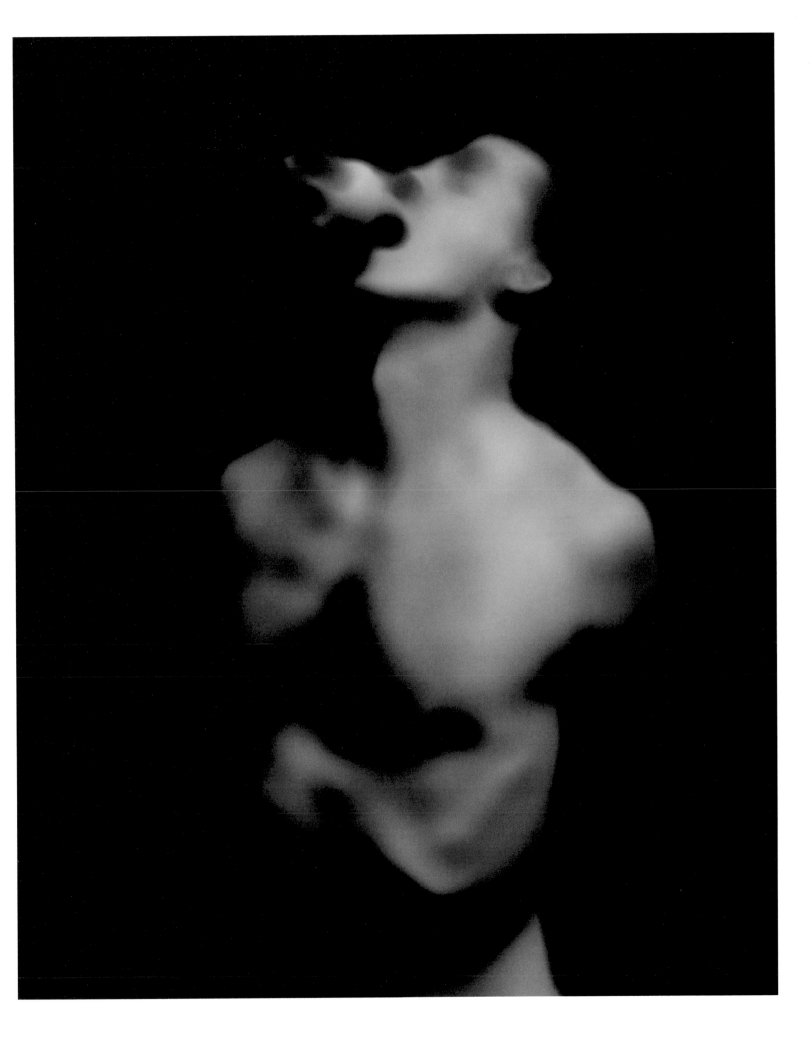

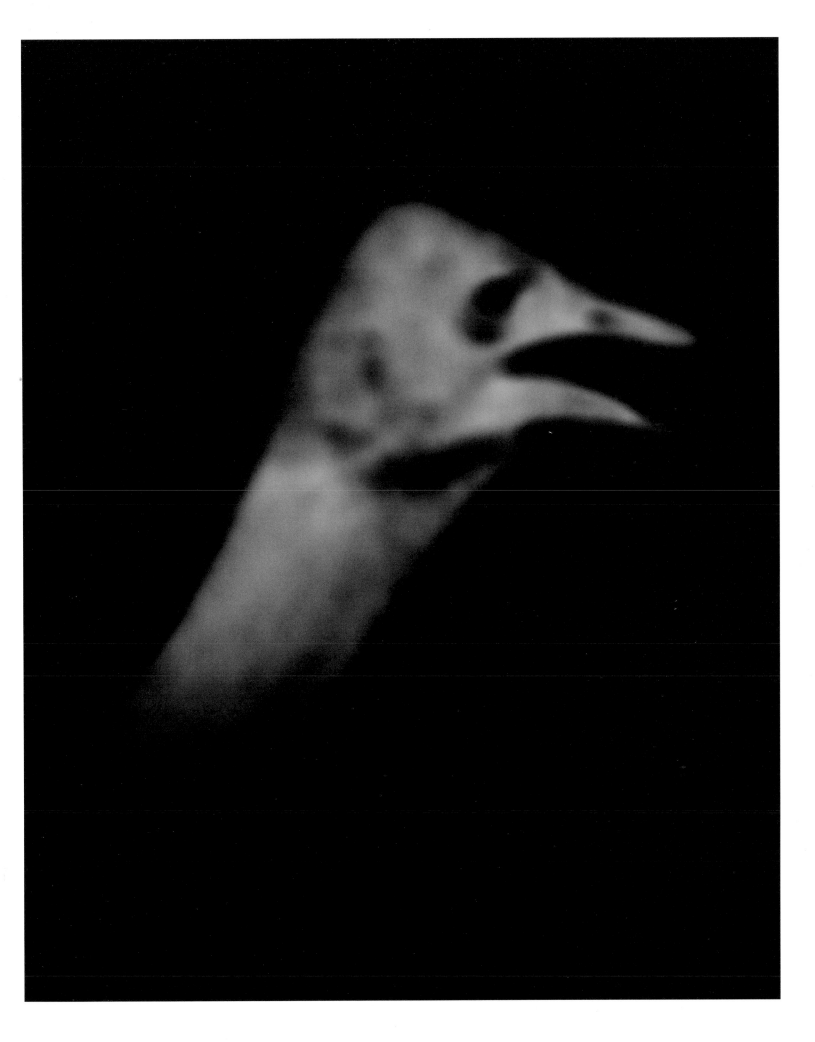

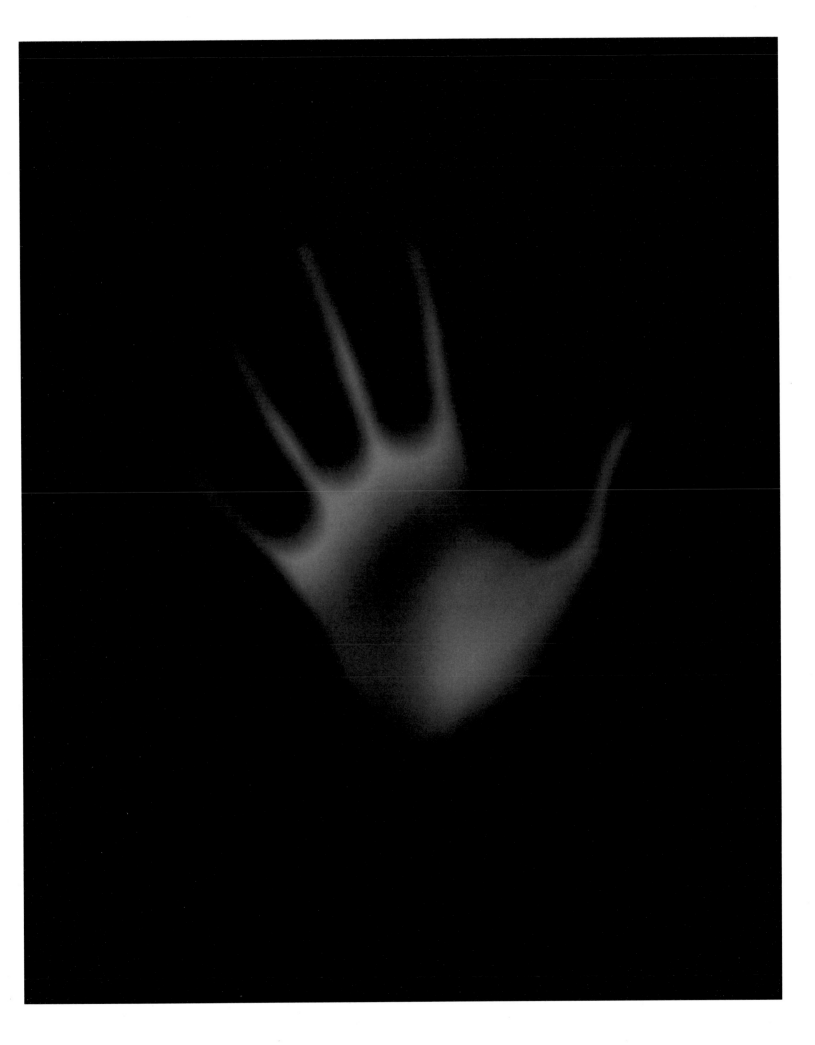

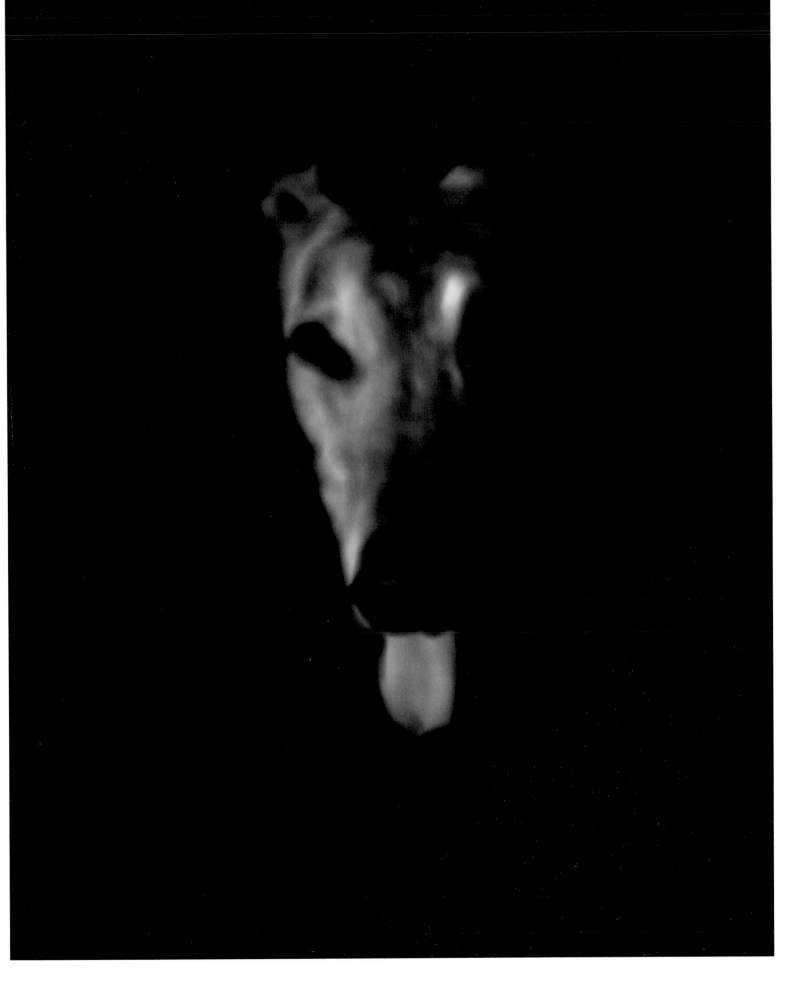

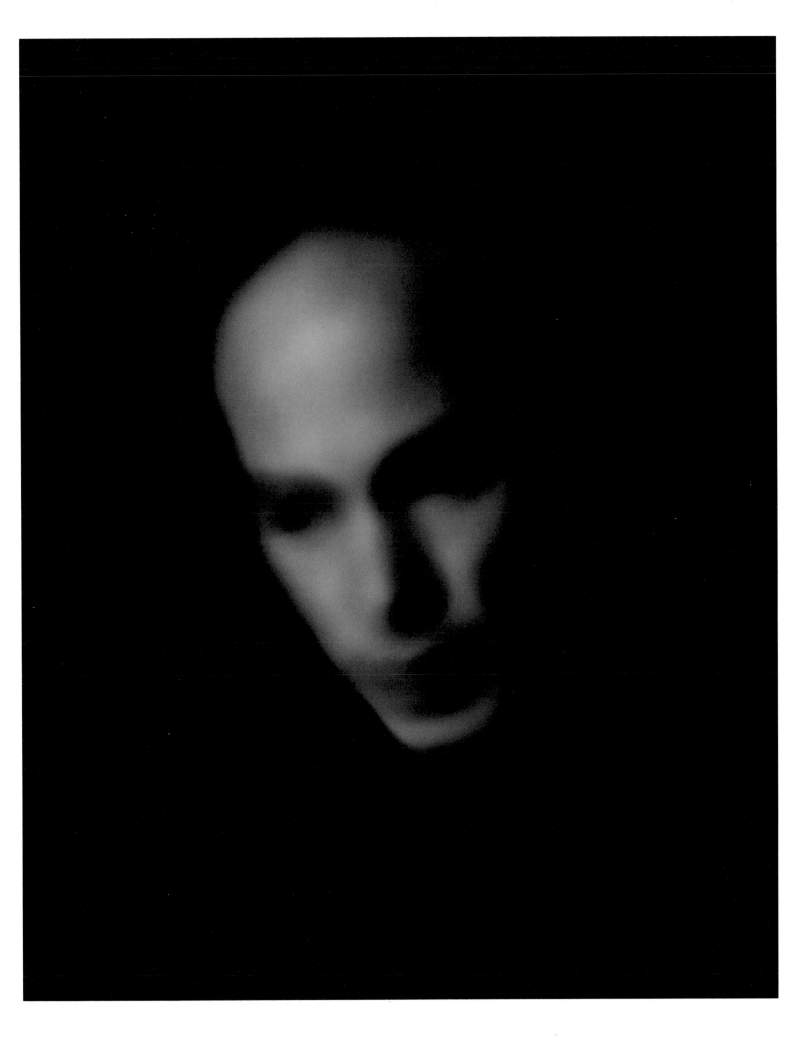

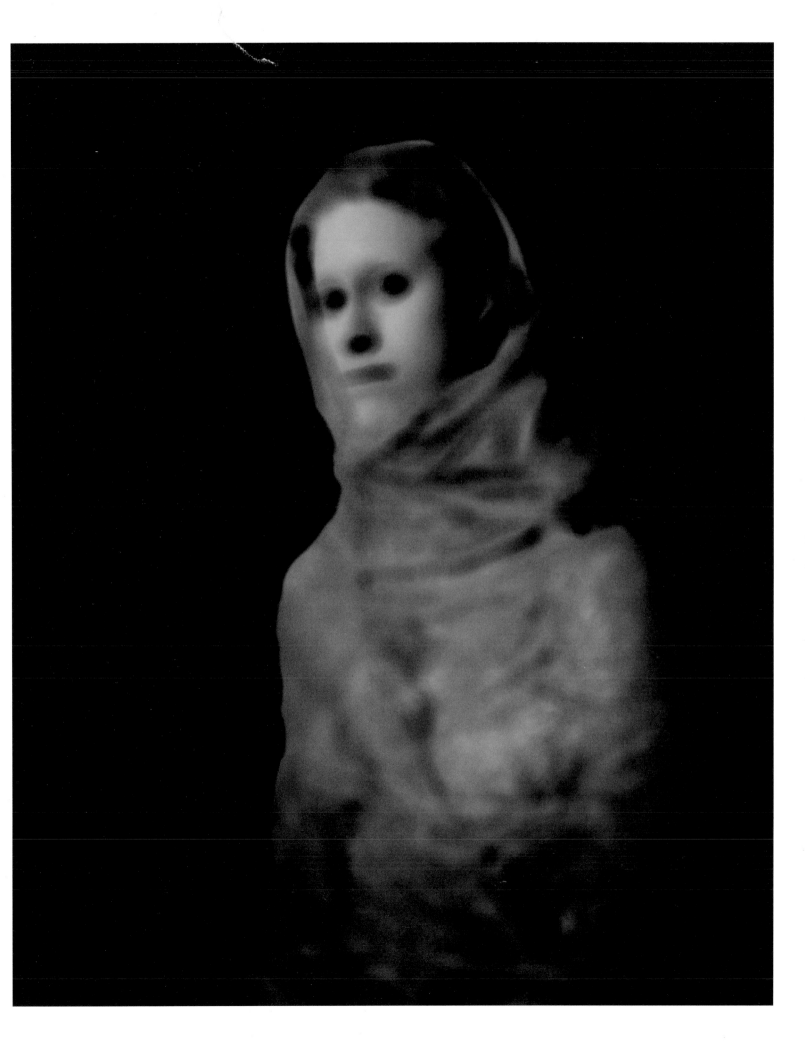

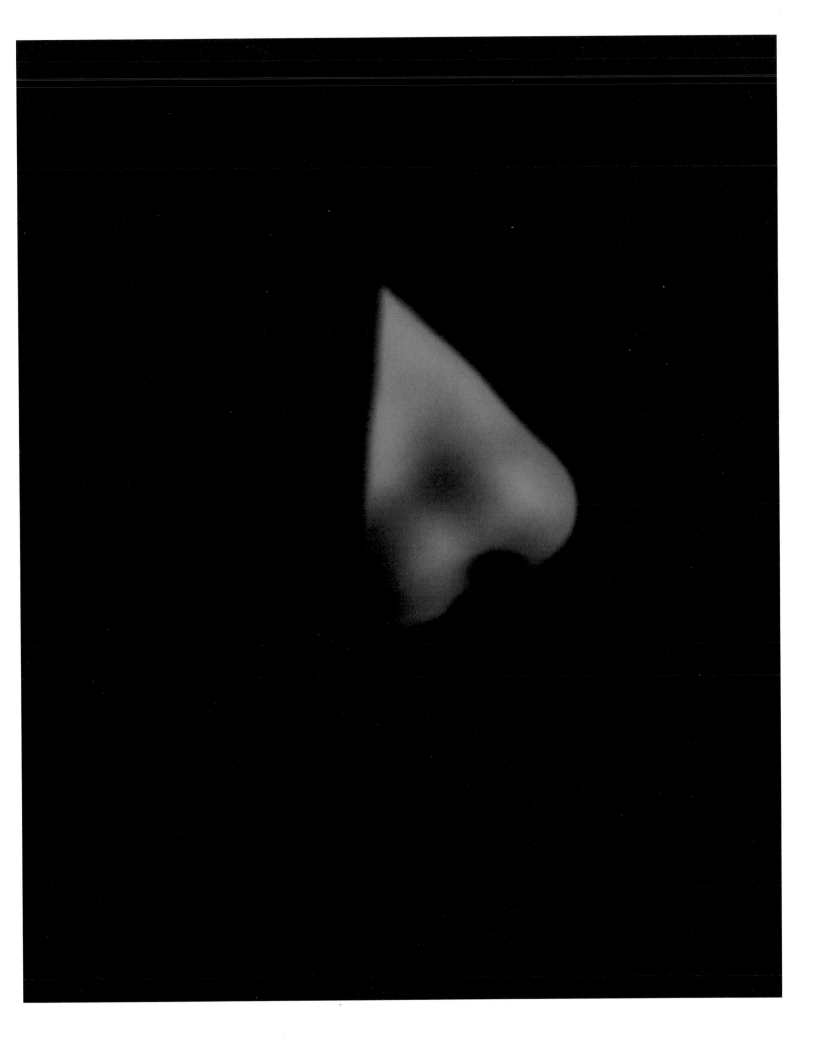

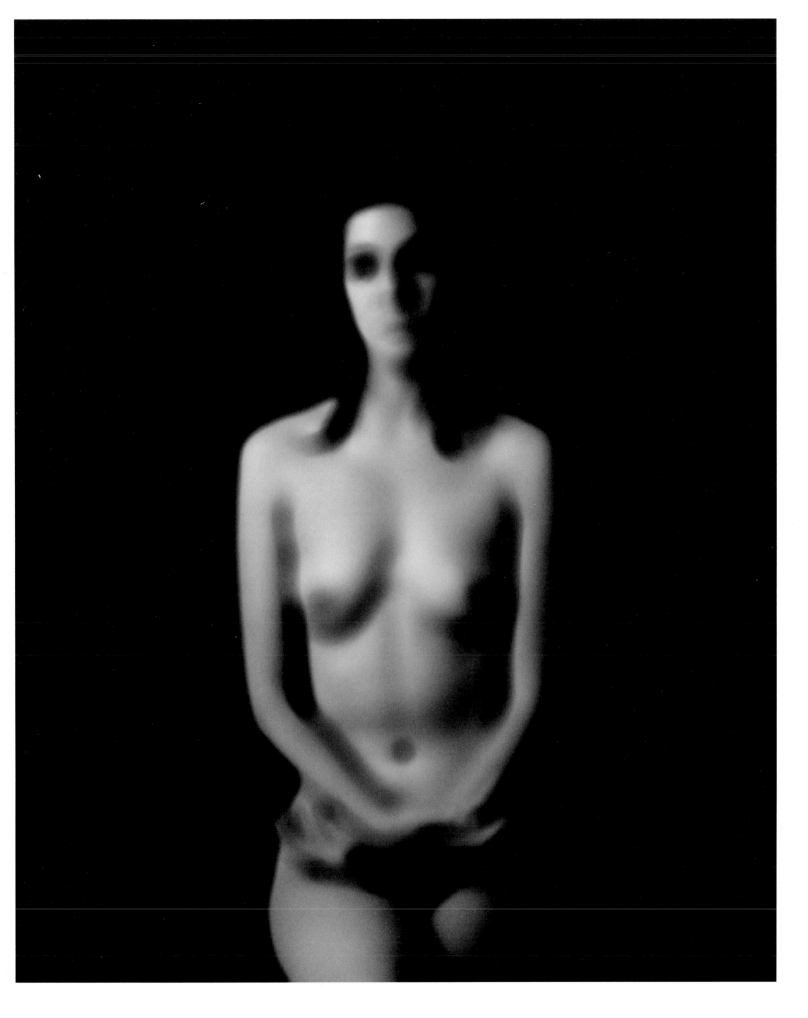

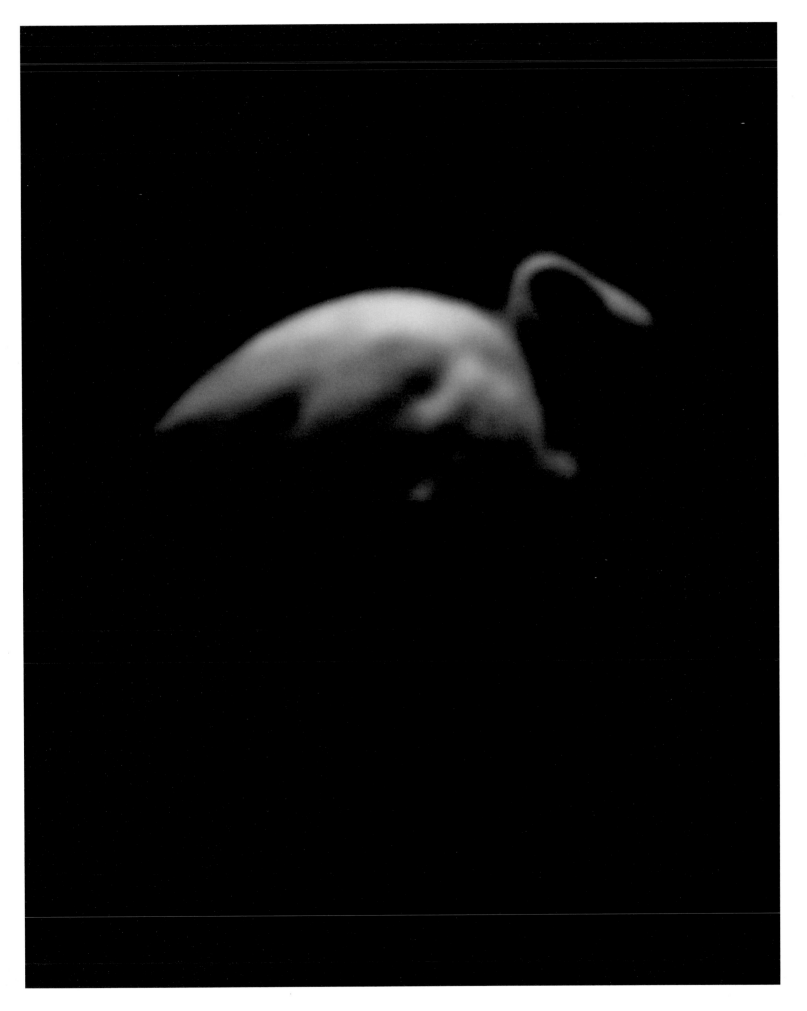

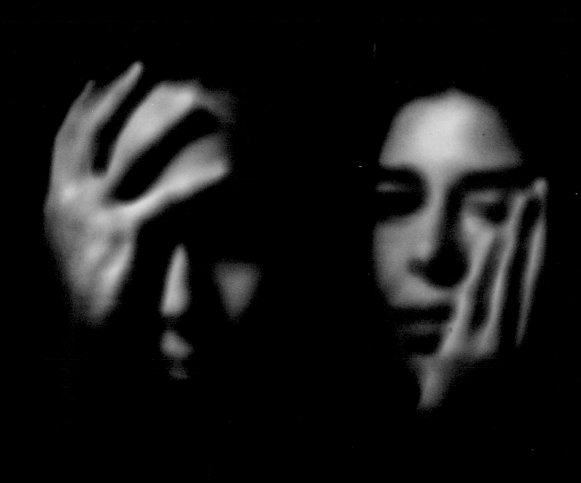

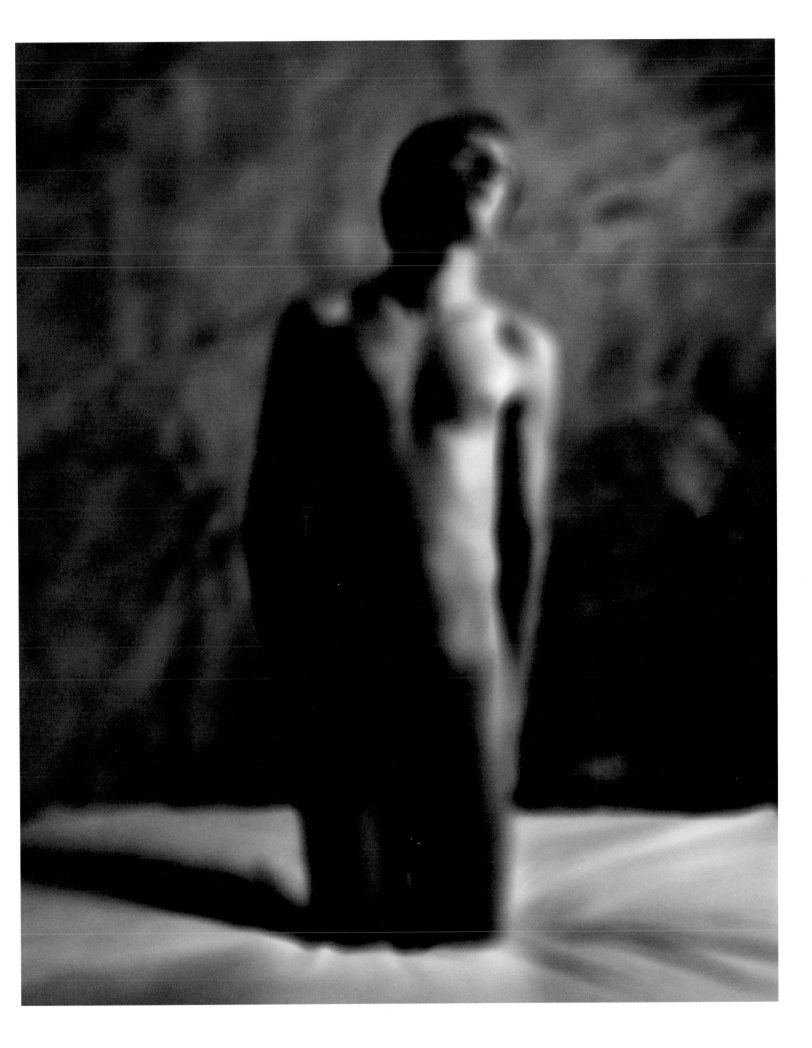

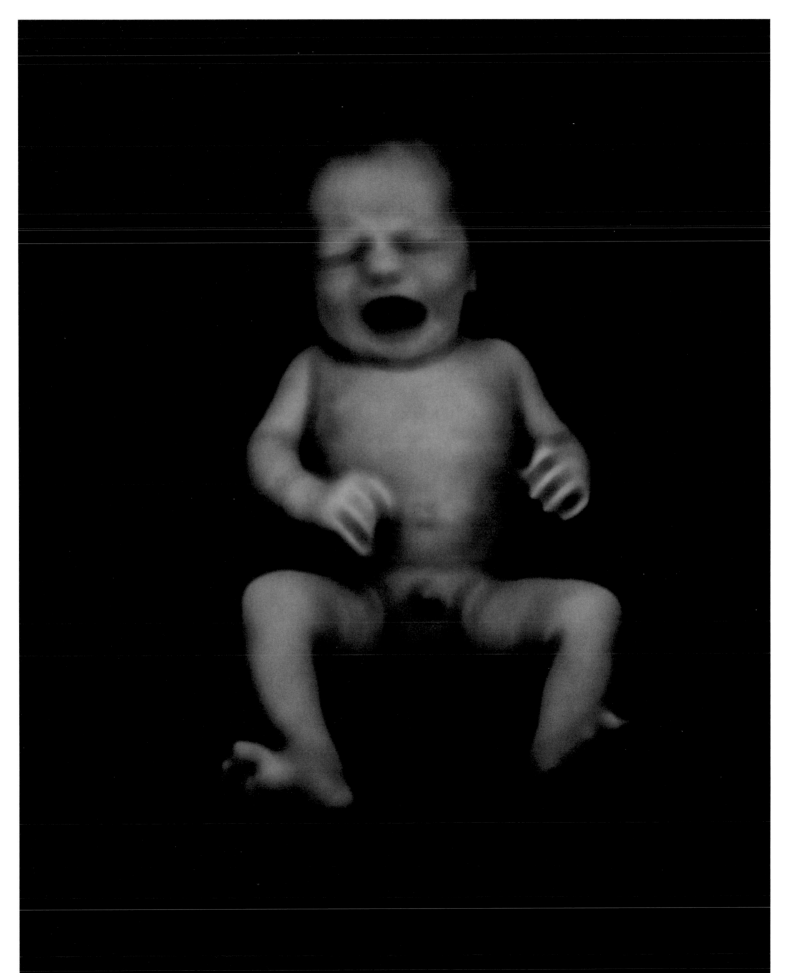

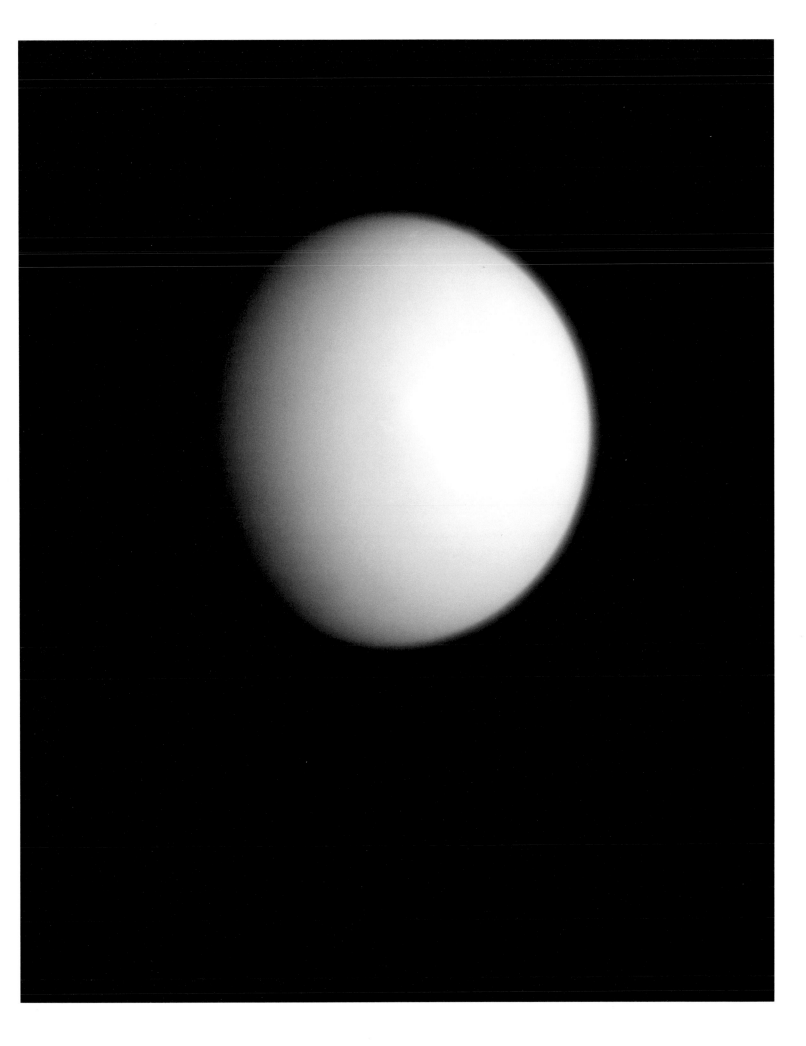

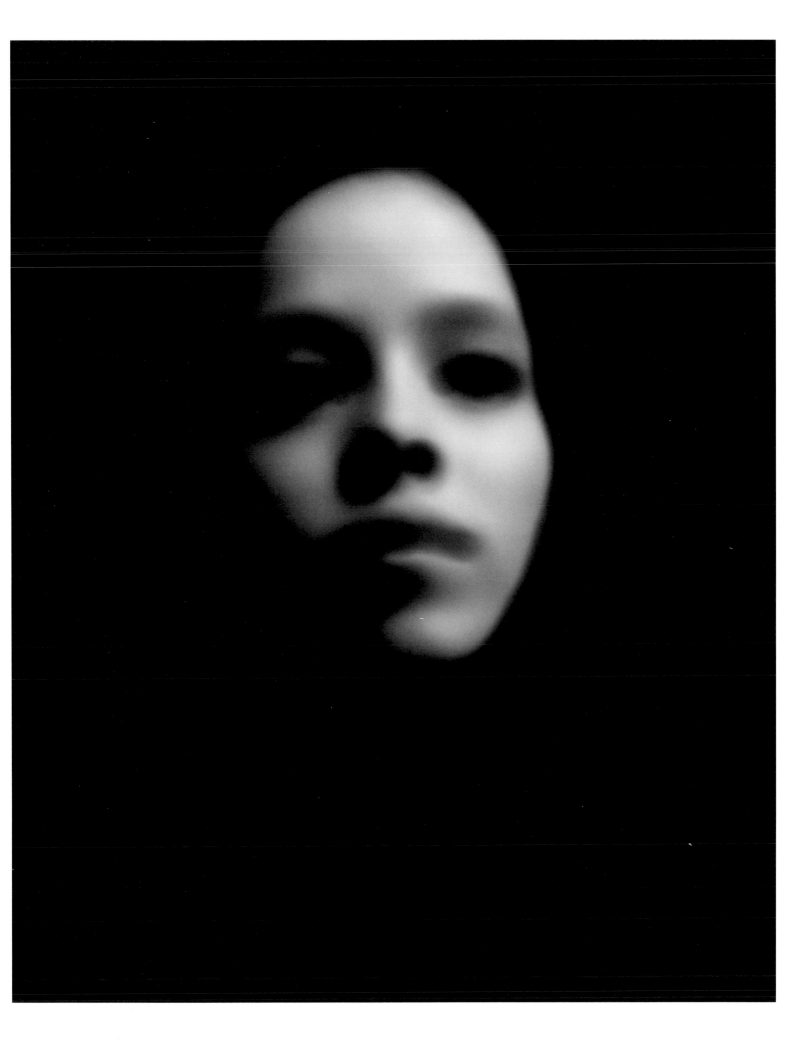

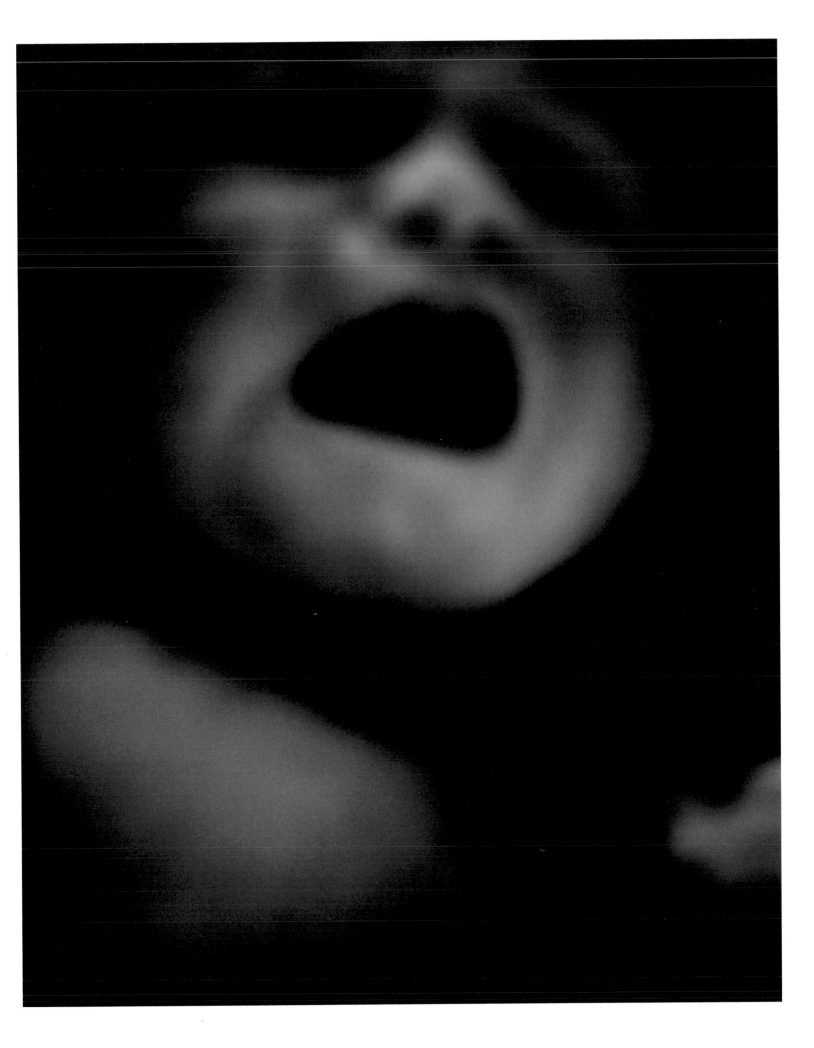

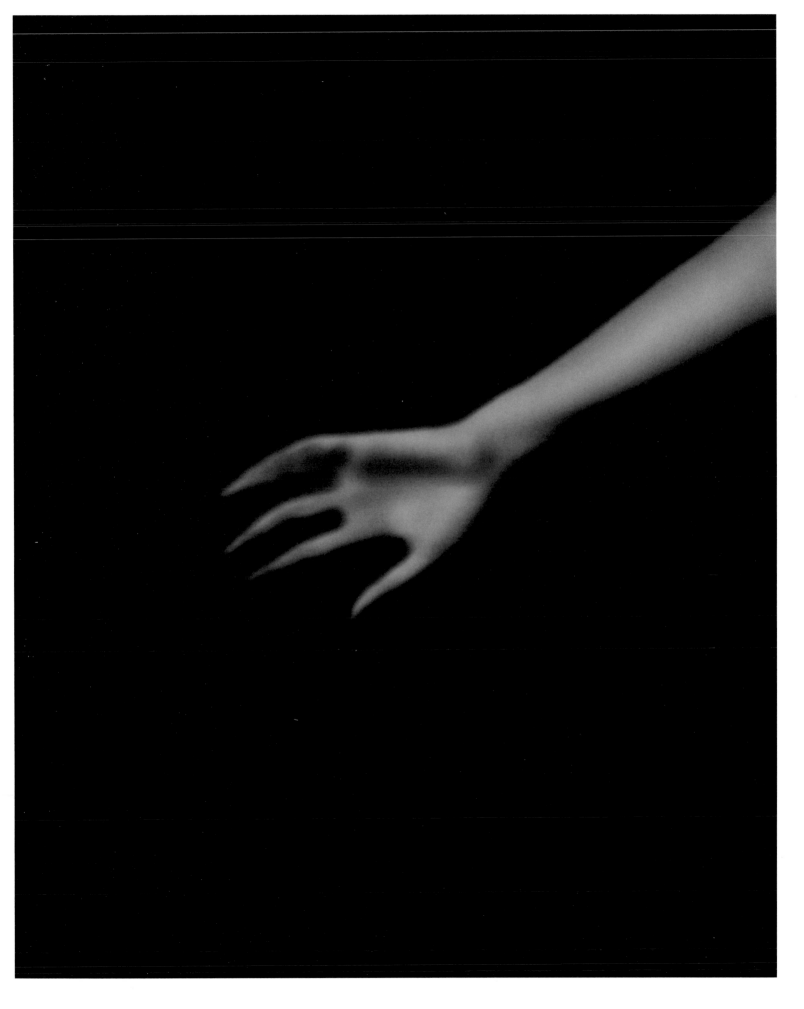

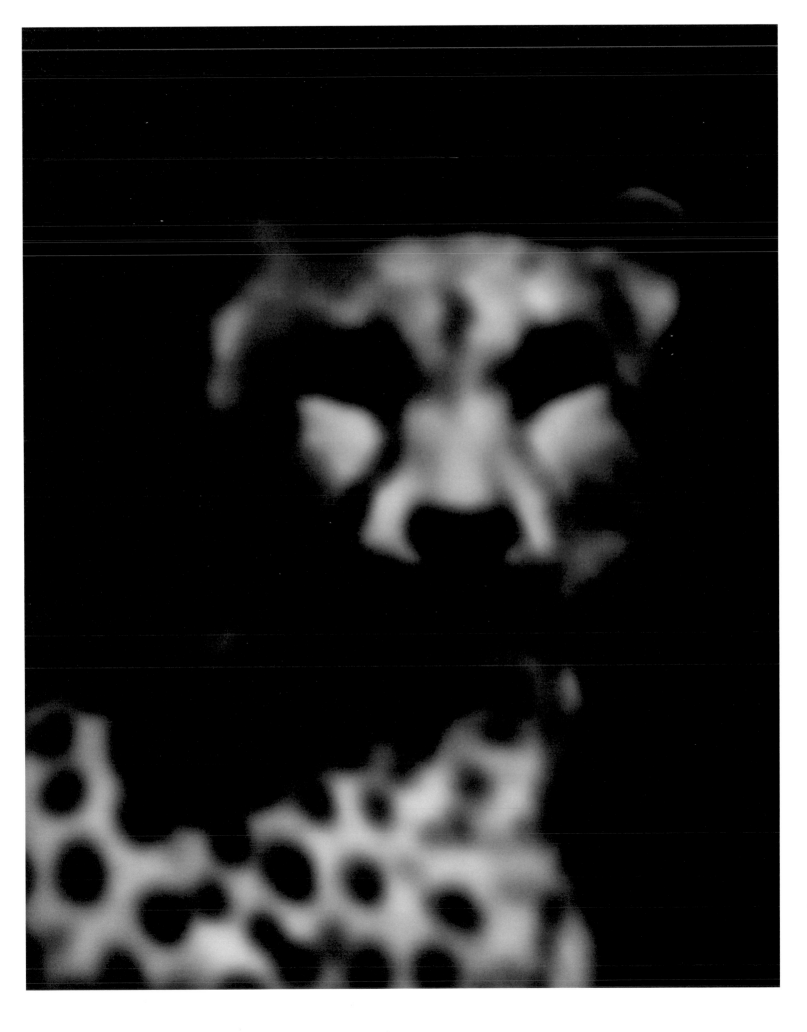

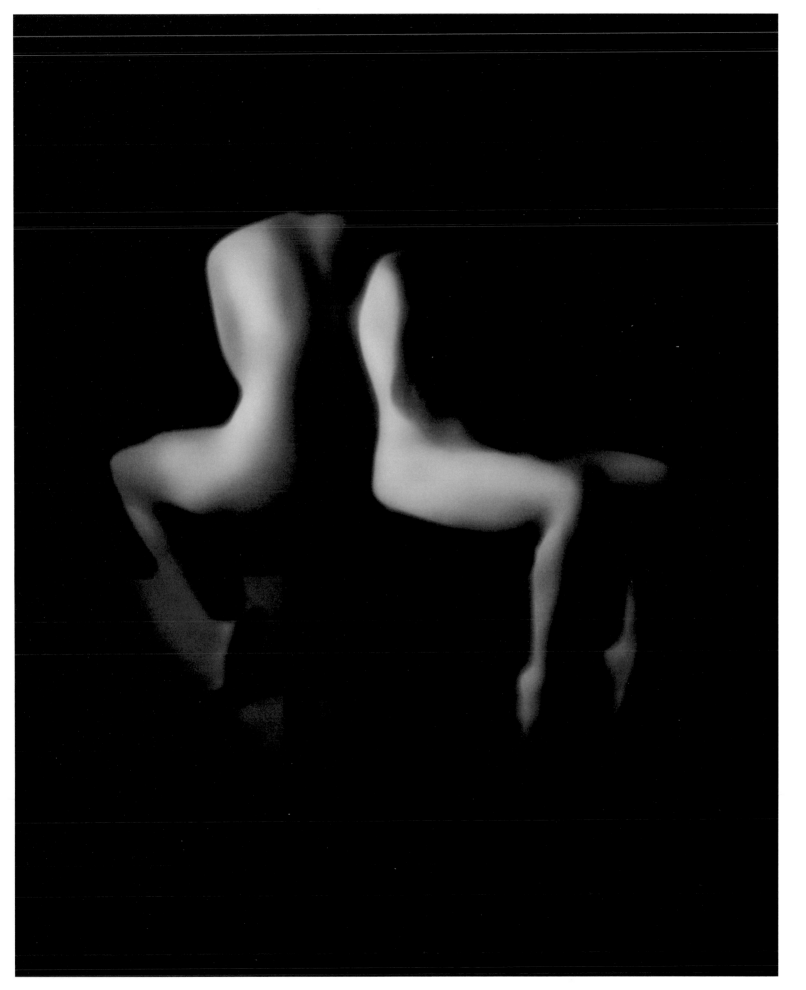

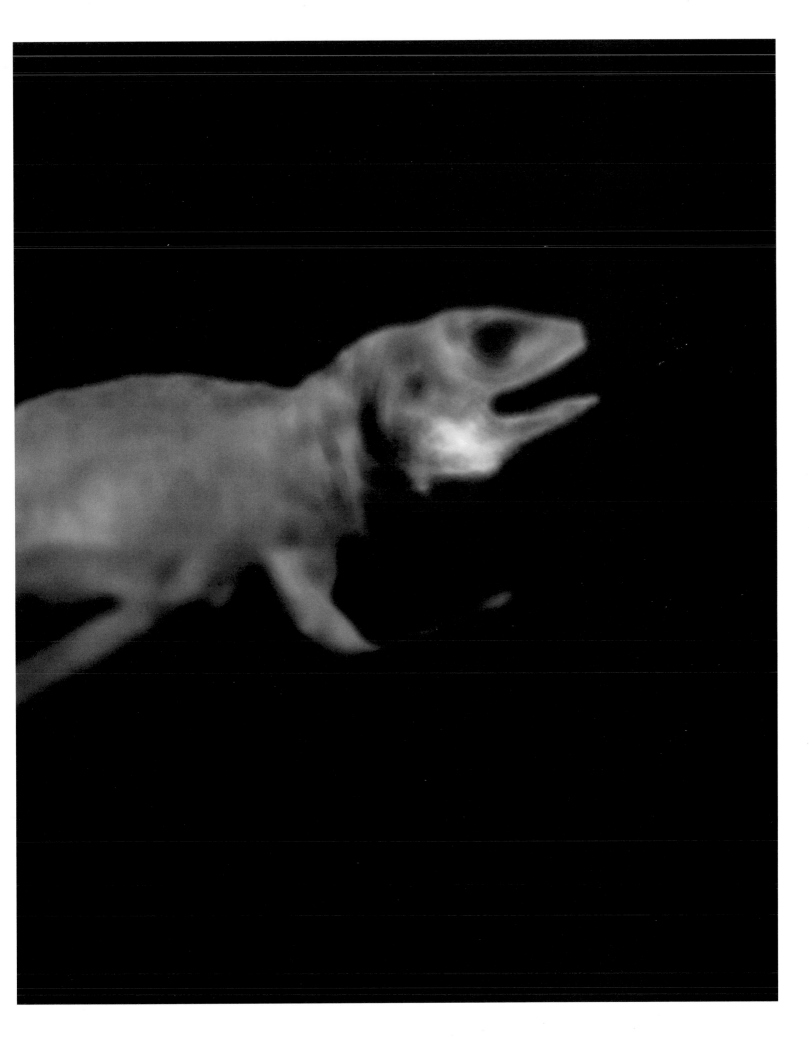

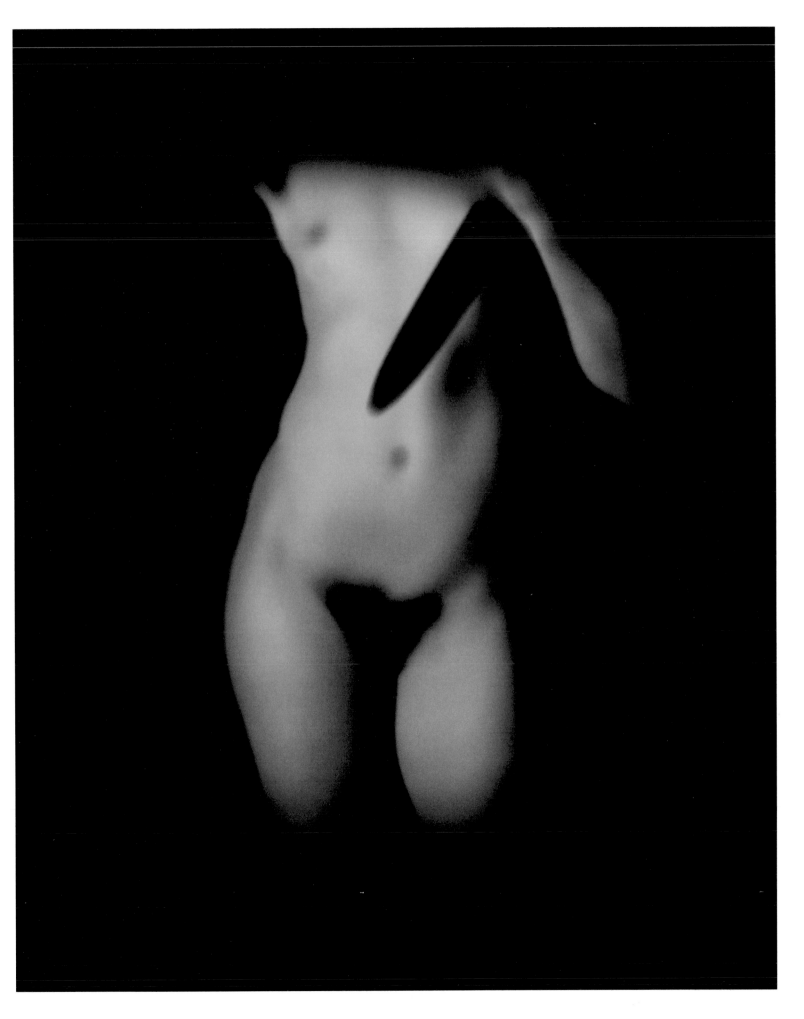

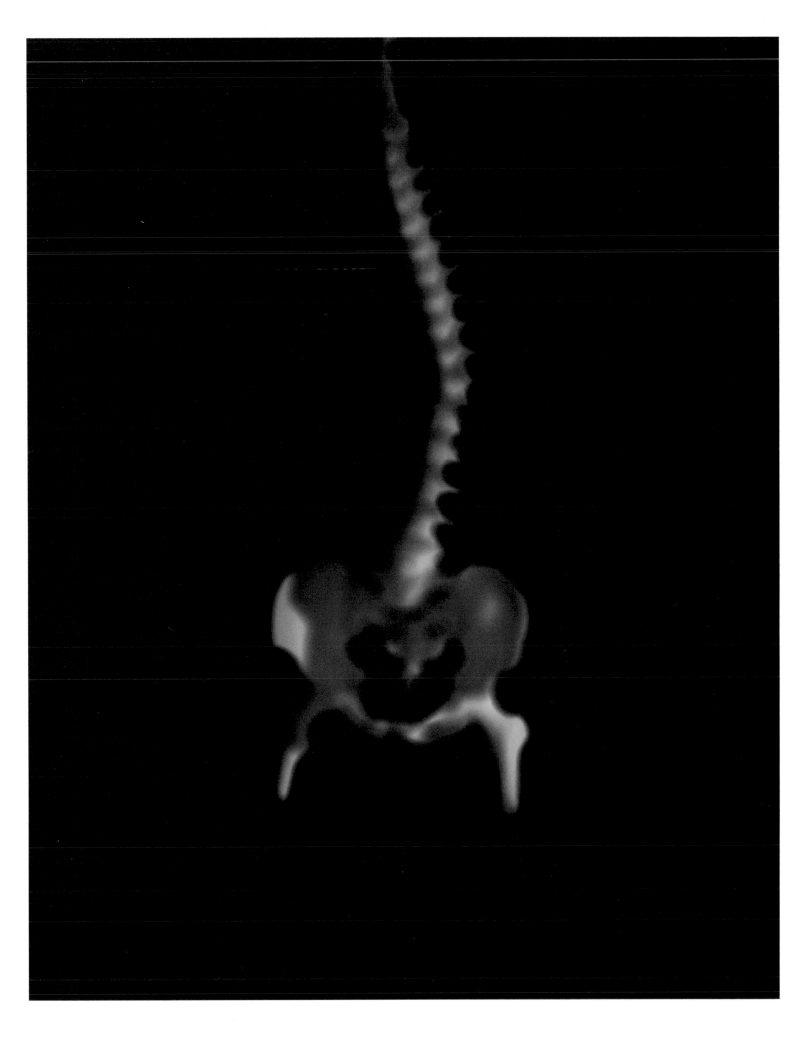

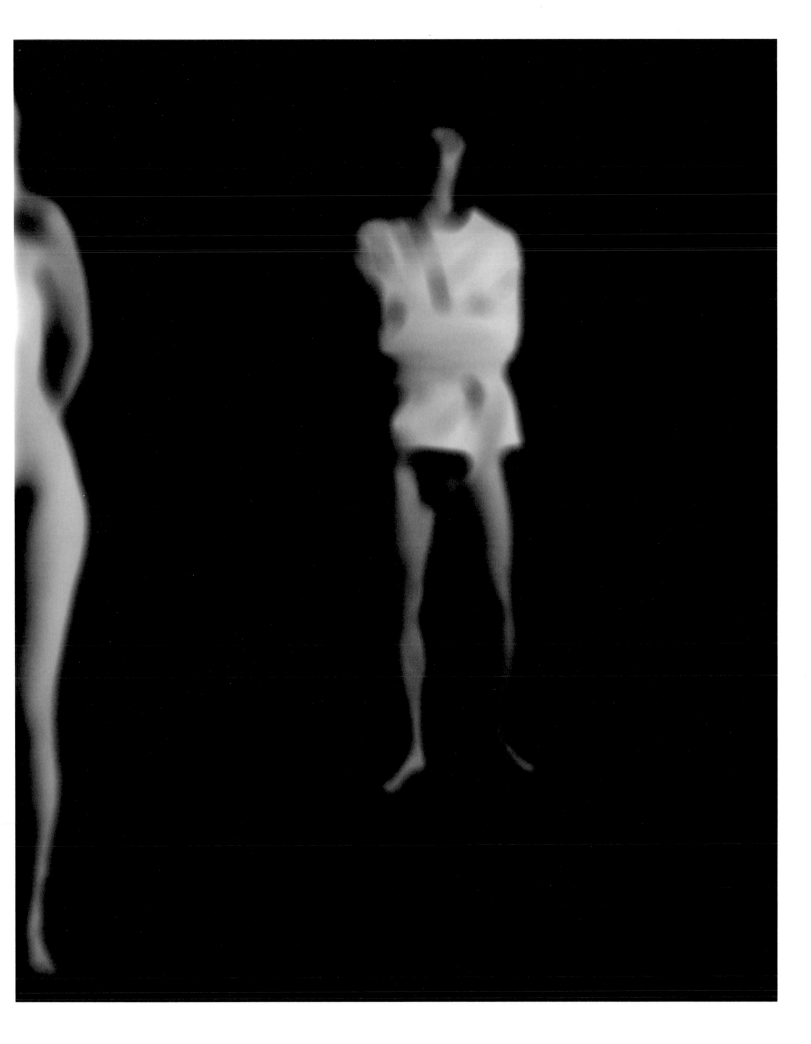

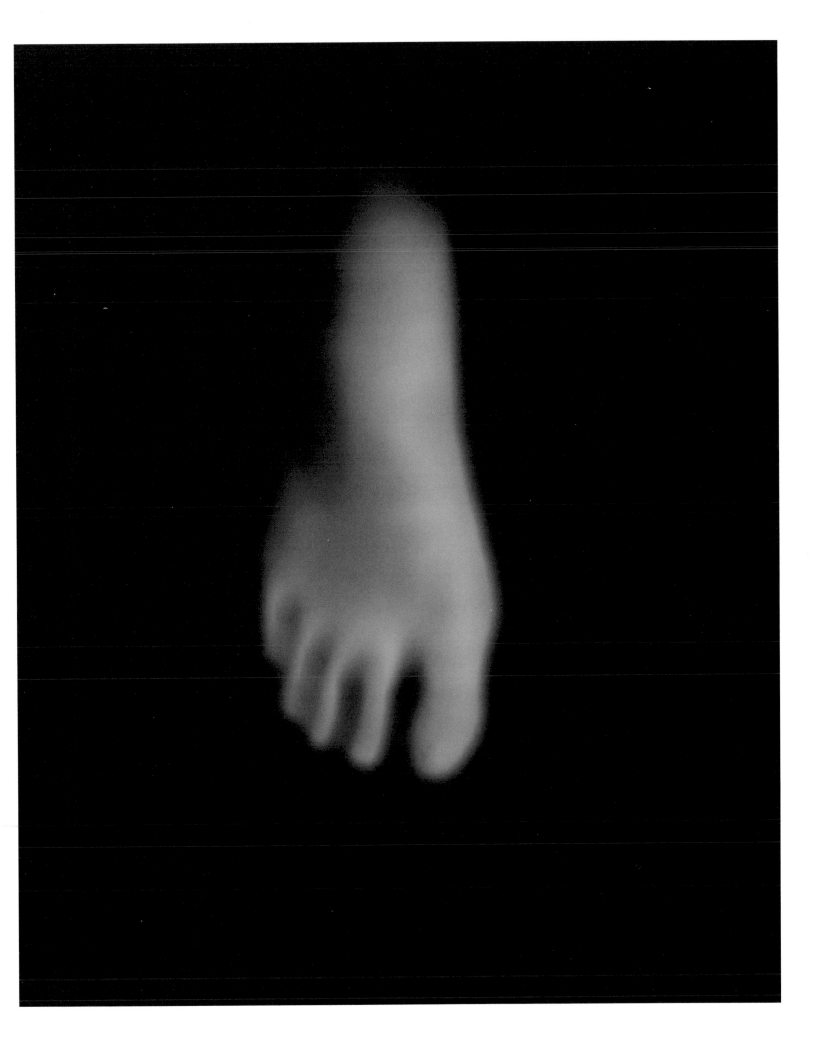

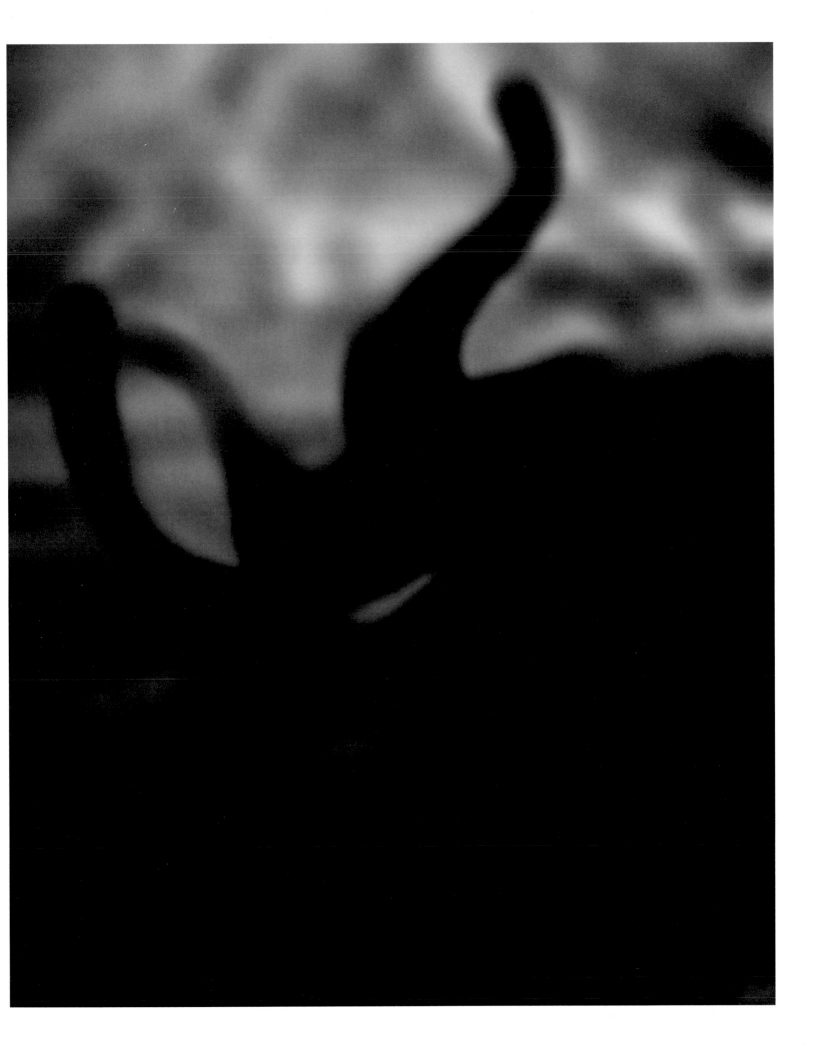

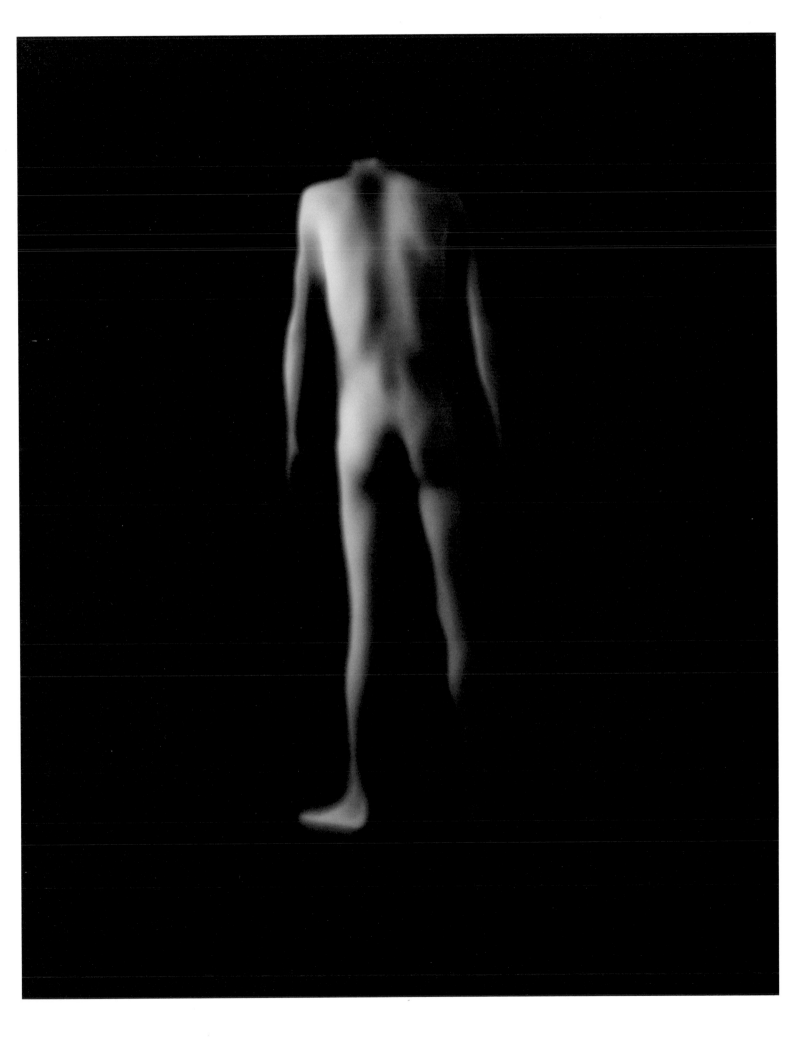

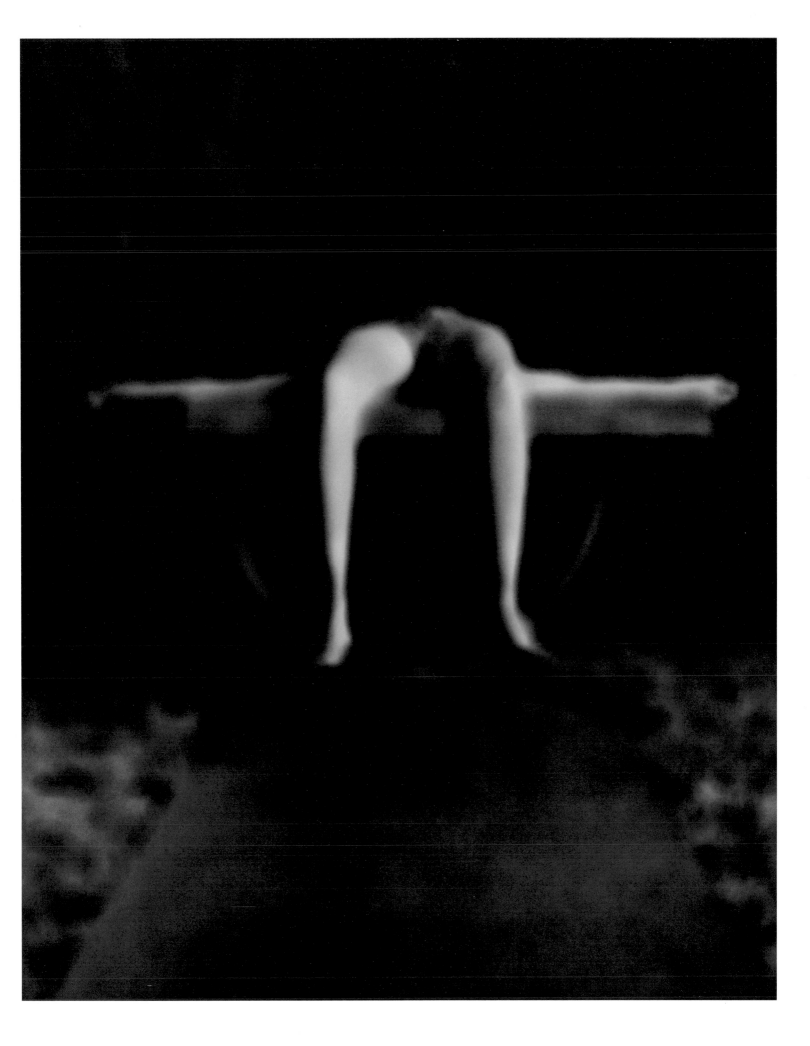

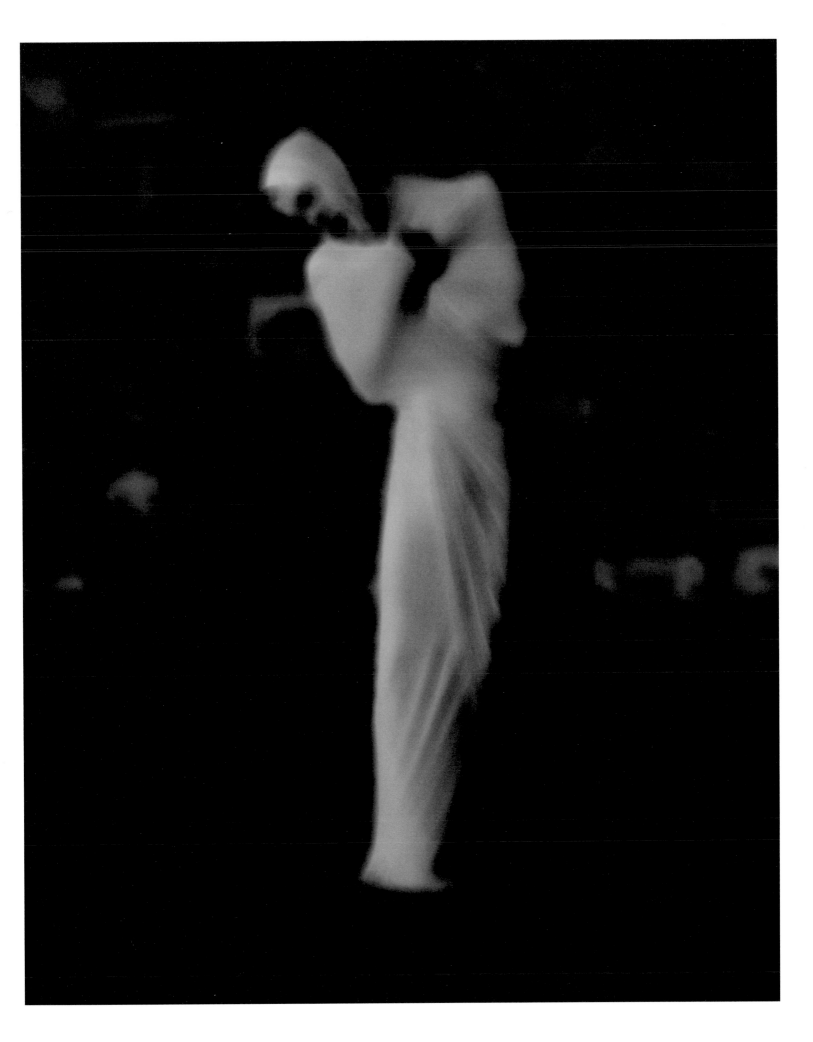

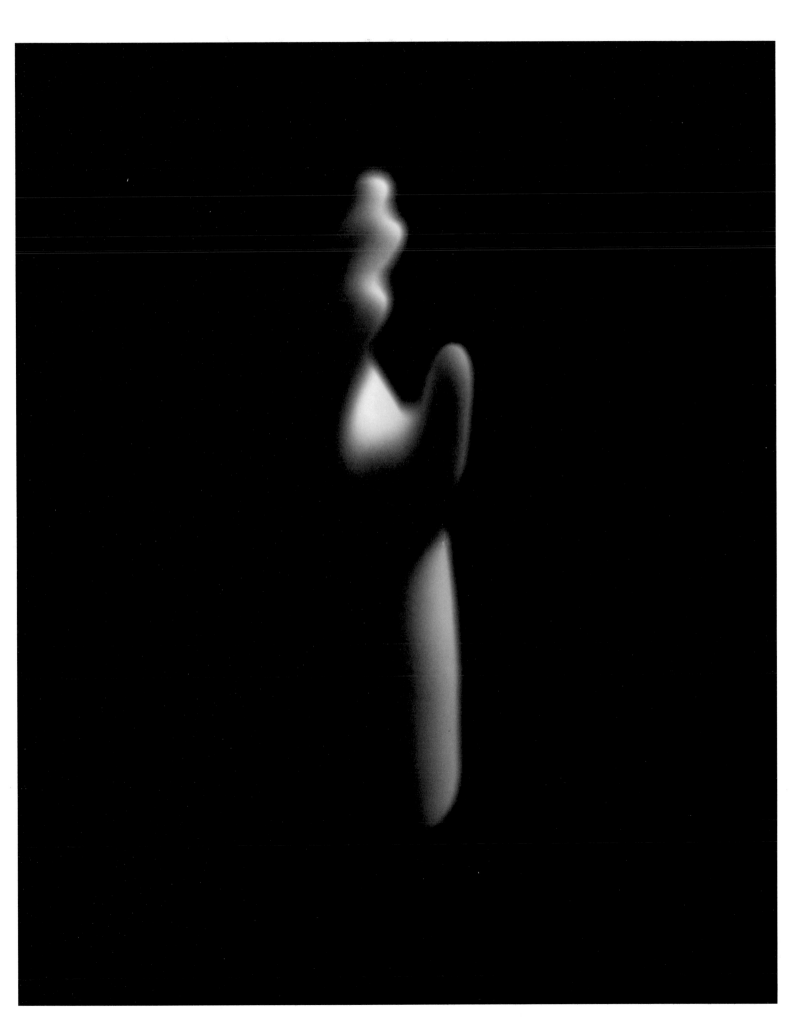

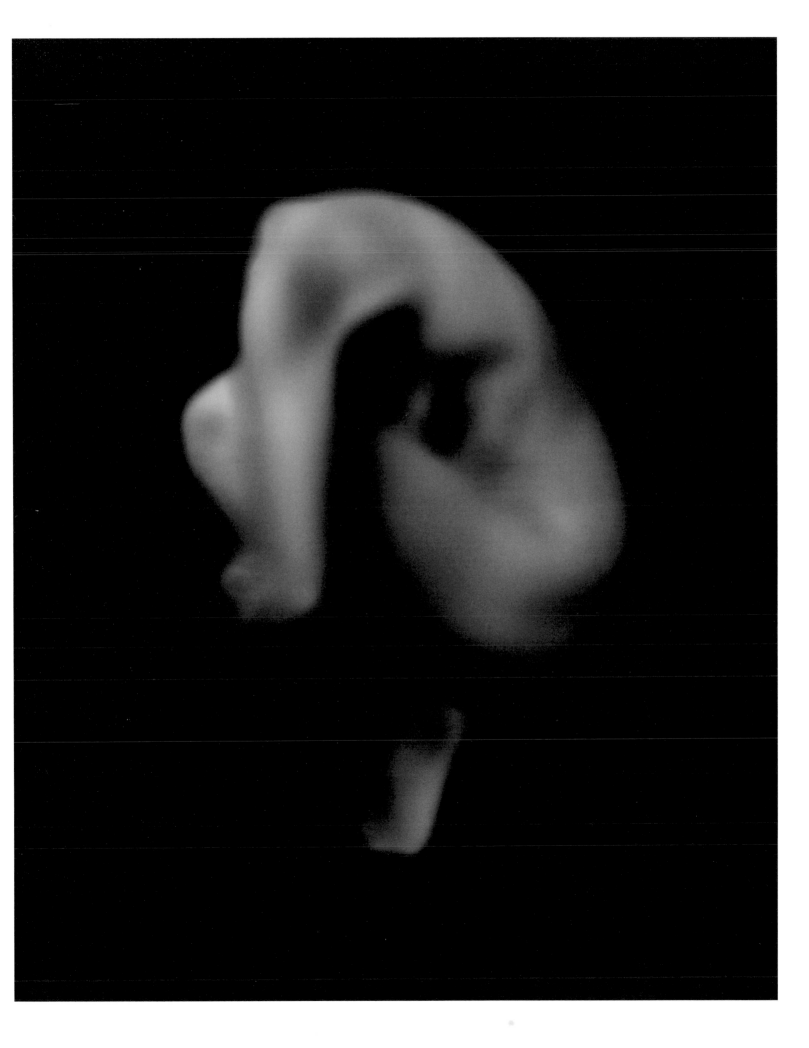

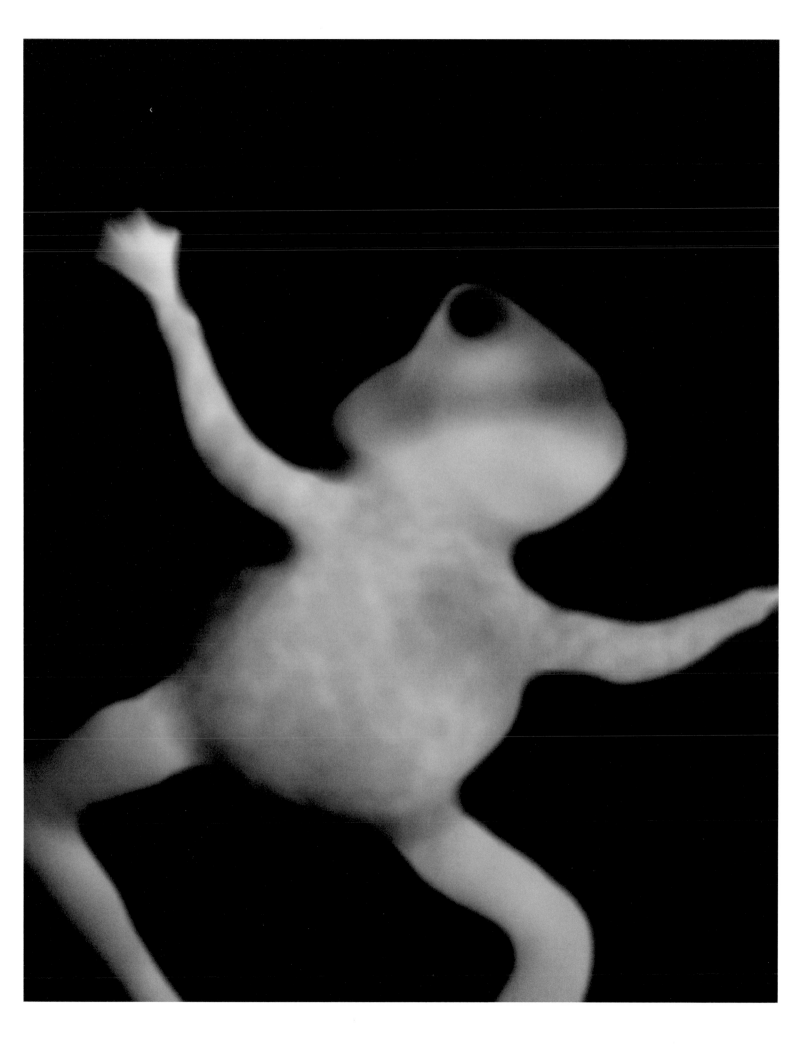

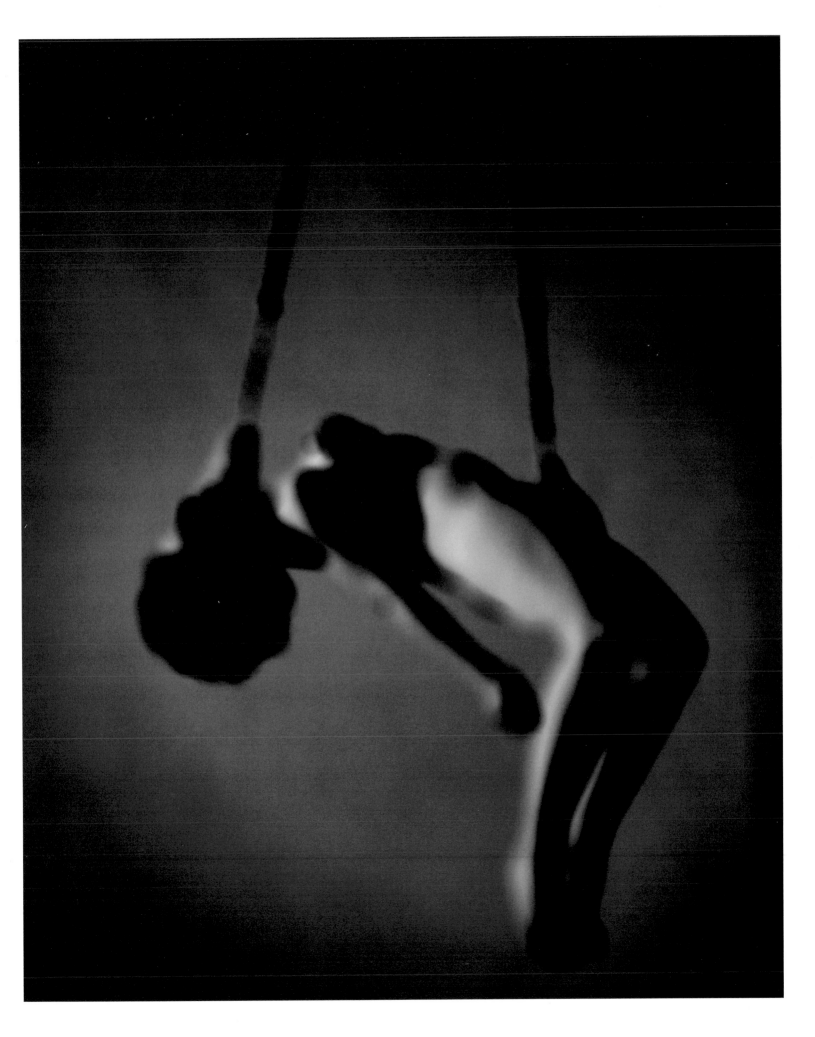

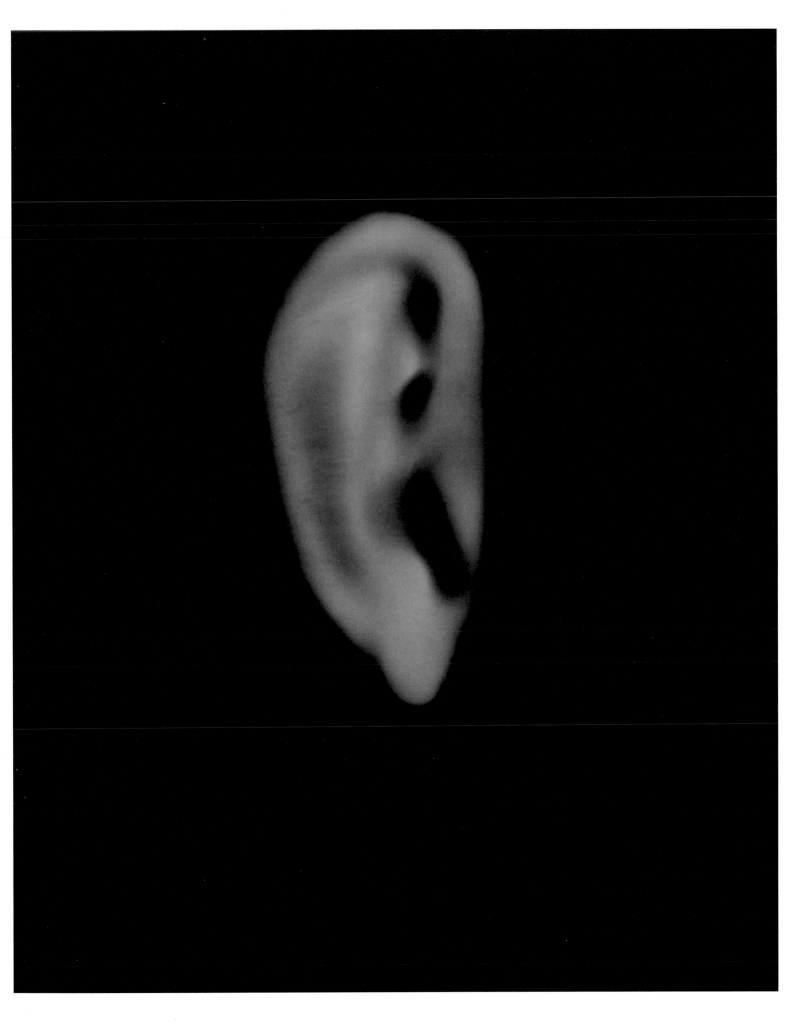

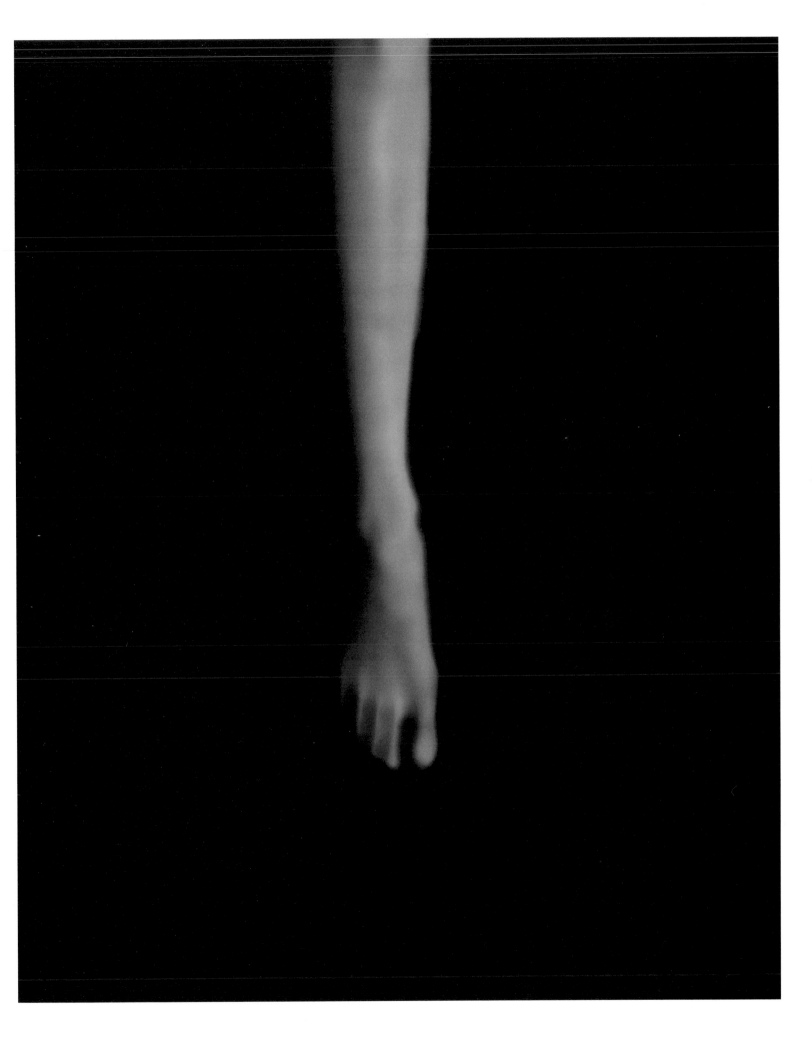

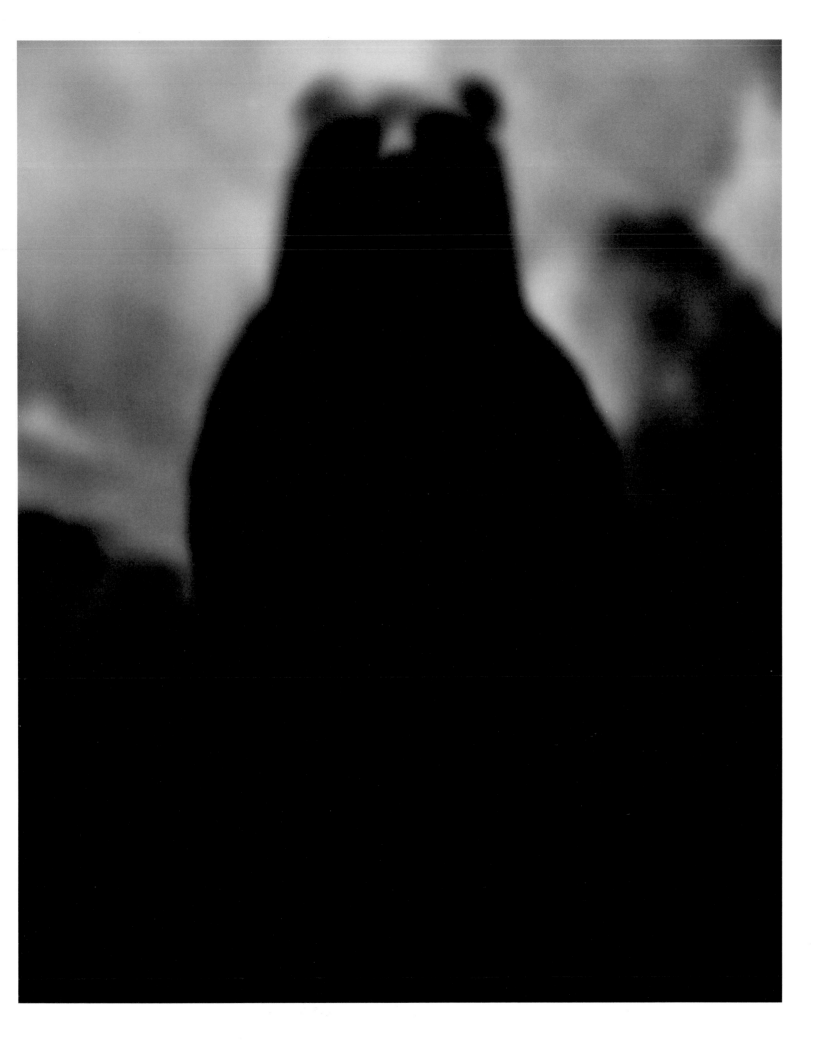

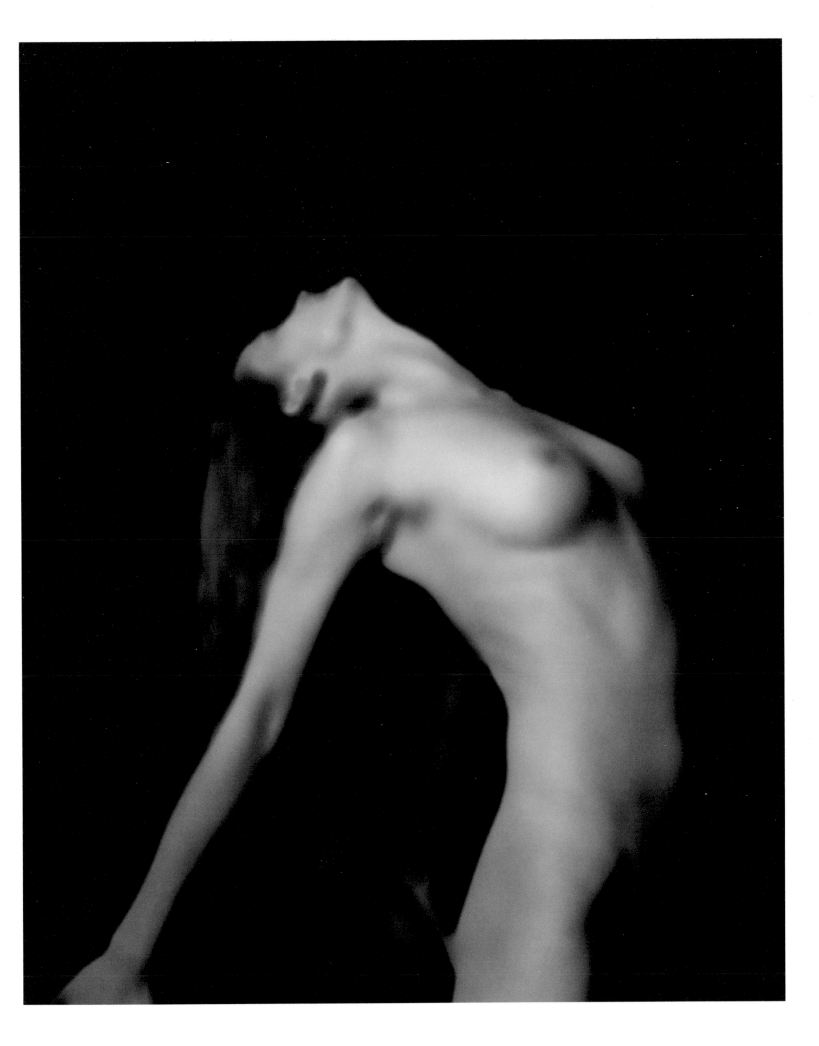

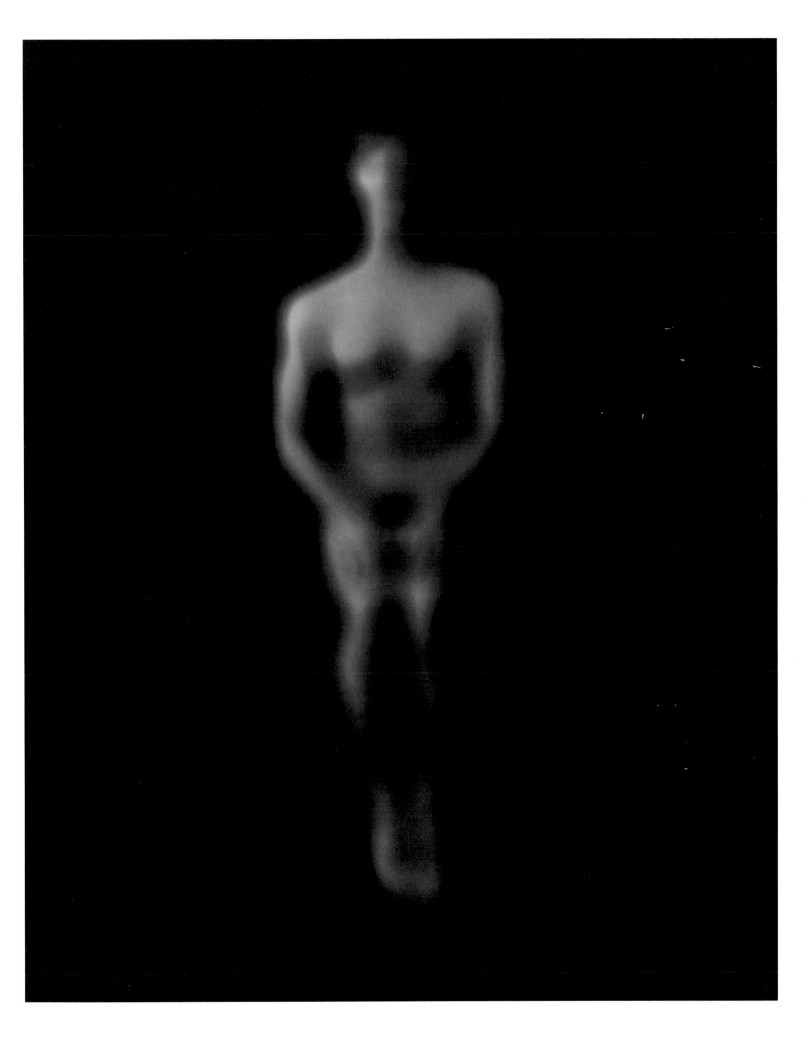

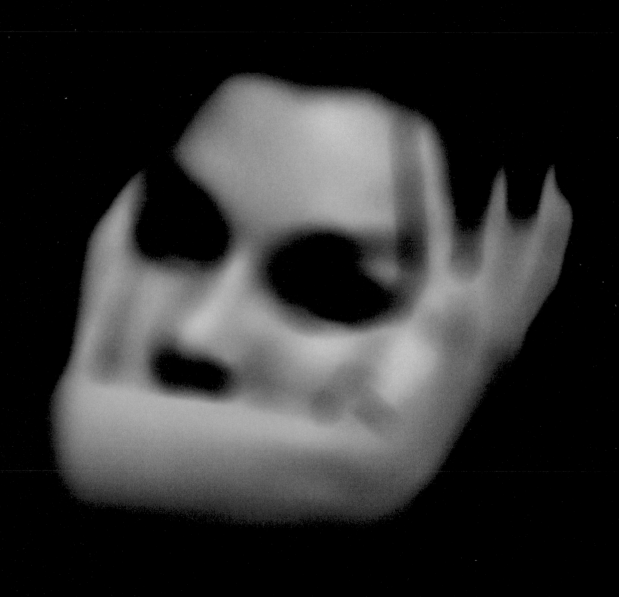

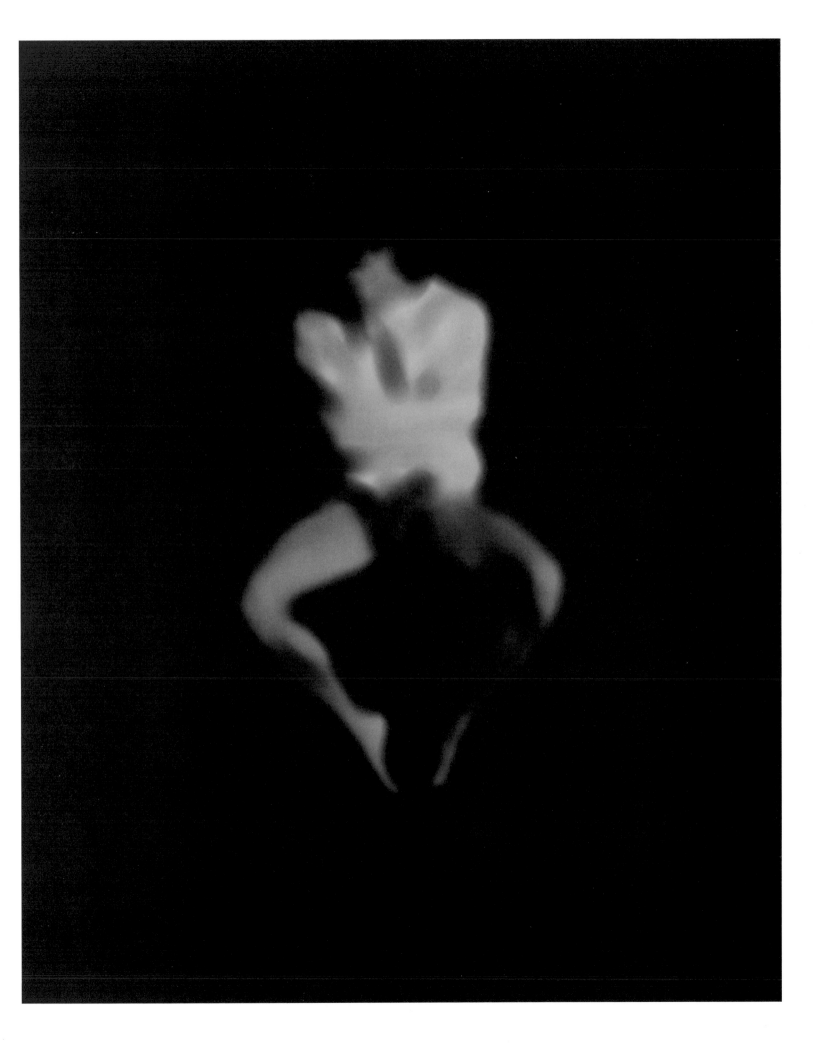

LIST OF PLATES

1/ *Self-Portrait in Water, #2*, 1991/1997

2/ *Head with Open Mouth*, 1995

3/ *Figure in Environment*, 1991/1994

4/ *Seated Man*, 1988/1994

5/ *Chair*, 1996

6/ *Bird*, 1996

7/ *Man with Object at Mouth*, 1992/1994

8/ *Ostrich*, 1996

9/ *Hand*, 1994

10/ *Dog, #2*, 1996

11/ *Man's Head, #1*, 1987/1994

12/ *Wrapped Woman*, 1994

13/ *Nose*, 1995

14/ *Seated Woman*, 1995

15/ *Flamingo*, 1996

16/ *Two Heads*, 1994

17/ *Man on Bed*, 1987/1995

18/ *Baby, #1*, 1994

19/ *Ostrich Egg*, 1997

20/ *Face*, 1997

21/ *Baby, #2*, 1994

22/ *Arm and Hand, #1*, 1996

23/ *Leopard*, 1997

24/ *Two Seated Figures*, 1994

25/ *Iguana*, 1997

26/ *Woman with Knife*, 1995

27/ *Spine*, 1996

28/ *Self-Portrait with Woman*, 1991/1995

29/ *Foot*, 1995

30/ *Elephants*, 1997

31/ *Man Standing (backside)*, 1991/1995

32/ *Man on Table*, 1995

33/ *Self-Portrait Wrapped*, 1993/1995

34/ *Arm and Hand, #2*, 1997

35/ *Crouched Figure*, 1995

36/ *Frog*, 1997

37/ *Woman Suspended*, 1994/1995

38/ *Ear*, 1995

39/ *Leg*, 1996

40/ *Bear*, 1996

41/ *Woman Arched*, 1996

42/ *Self-Portrait*, 1991/1994

43/ *Face with Hand, #2*, 1995

44/ *Self-Portrait, Seated*, 1995

All images are from Series Number Five and are gelatin silver prints.

Robert Stivers (b. 1953) has shown his work extensively in the United States and Europe. His photographs are in the collections of the Los Angeles County Museum of Art, The Museum Ludwig, and The Victoria and Albert Museum of Art. The artist currently lives and works in Santa Fe, New Mexico.

A.D. Coleman lectures, teaches, and publishes widely both here and abroad. His writing has appeared in the *Village Voice, The New York Times, Artforum, Art in America, ArtNews,* and *Photography in New York.* His published books include *Critical Focus: Photography in the International Image Community, Tarnished Silver: After the Photo Boom,* and *The Grotesque in Photography.*

Acknowledgements

Terence Brewer, A.D. Coleman, Alexandra Ewing, Helene Greenberg-Wyman, Gail Ironson, Stanley Klimek, New Mexico Dance Coalition, Ann Nisenson, Yancey Richardson Gallery, New York, Andrea Senutovitch, Gary Simpson, Sean Simpson, Elizabeth Stivers, Margaret Lynn Stivers, Alden Stupfel, Spencer Throckmorton, Turner Carroll Gallery, Santa Fe, New Mexico, and Visions Photo Lab, Santa Fe, New Mexico.

Special thanks go to Eliza Lovett Randall, and to James Crump.

For My Parents, Robert and Margaret Stivers

FIRST EDITION PUBLISHED BY ARENA EDITIONS,
243 Closson Street, Suite 12, Santa Fe,
New Mexico 87501-2533, USA
Telephone 505-986-9132; Fax 505-986-9138.
WEBSITE: www.arenaed.com

CONCEPT AND ART DIRECTION: James Crump
BOOK DESIGN AND TYPOGRAPHY: Elsa Kendall

DISTRIBUTION by D.A.P./Distributed Art Publishers,
155 Sixth Avenue, New York, NY 10013.
Telephone 212-627-1999; Fax 212-627-9484

SEPARATIONS by Nova Concept, Berlin

PRINTED in Novatone ® by EBS, Verona - Italy

FIRST EDITION, 1997

ISBN 0-9657280-0-5